Getting Started in Digital Photography:

From
Snapshots to
Great Shots

Khara Plicanic

Peachpit
Press

Getting Started in Digital Photography: From Snapshots to Great Shots
Khara Plicanic

Peachpit Press
www.peachpit.com

To report errors, please send a note to errata@peachpit.com

Peachpit Press is a division of Pearson Education

Material also published as *Your Camera Loves You: Learn to Love It Back,* Peachpit Press,
© 2012, ISBN-13: 978-0-321-78410-0

Acquisitions Editor: Ted Waitt
Associate Editor: Valerie Witte
Production Editor: Lisa Brazieal
Composition: WolfsonDesign
Indexer: James Minkin
Cover Design: Aren Straiger
Cover Image: Khara Plicanic
Interior Design: Riezebos Holzbaur Design Group and WolfsonDesign

ISBN-13 978-0-321-95654-5
ISBN-10 0-321-95654-0

9 8 7 6 5 4 3 2 1

Printed and bound in the United States of America

DEDICATION

To those who seek a life beyond "auto" mode.

ACKNOWLEDGMENTS

Group hug for the entire Peachpit crew! Including, but not limited to, Lisa Brazieal, Scott Cowlin, Andreas F. S. deDanaan, Mimi Heft, Kelly Kordes Anton, Joy Dean Lee, Sara Jane Todd, Myrna Vladic, Ted Waitt, Liz Welch, Valerie Witte, and WolfsonDesign. You are all quite simply—amazing.

Robin Williams, whose generosity aligned the stars and eventually made this book a reality. From Santa Fe to London, and everywhere in between—a million thanks.

Jim and Maria Lintel—the best parents in the world! In addition to your unwavering love and support, I thank you for the many ways you have helped shape my life, my teaching—and ultimately, this book. I love you.

And finally, this book literally would not be the same without my incredible husband Emir. (Love you!) Whether helping with illustrations, graciously posing for a photo, putting up with countless late nights (very late nights), letting me play on the other side of the lens now and then, or simply being there when I needed you—you are my unwavering hero. Go team!

Contents

Introduction

Your digital camera loves you. It always has. Sure, it gets stuck shooting in "auto" mode most of the time and graciously takes the blame when the photos aren't what you'd hoped for. And yet, it's still there for you. Silently waiting and patiently hoping for that one day—the day you come around and realize how good you've had it all along, finally giving it the chance to live up to all the impressive functionality it was built for. (Cue the heroic music.)

But, more often than not, before your camera ever gets the chance to shine, it gets kicked to the curb by a newer model. A neighbor, friend, or relative innocently shows off his or her latest camera acquisition—and before you know it, you're smitten. You are certain, beyond a doubt, that a new camera will solve all your photo problems. A newer/fancier/more mega-pixel-y camera will make all your bad photos a thing of the past, right?!

Sorry to break it to ya, but the problem isn't your camera. And the idea that buying a new one will magically morph your pictures into photographic gold is like believing that a new high-end glue gun will make you the next Martha Stewart. (Just bein' honest, folks!)

The path to better pictures starts not with a new camera, but with learning to use the one you've got. As it turns out, cameras don't take great photos—people do. And believe it or not, people have created incredible images with cameras made from an oatmeal box (seriously). The buck stops here.

REALLY, ANY CAMERA WILL DO!

In an effort to prove that having a fancy camera isn't required to capture stunning photos, I made a point of including images in this book that were captured with a variety of cameras, ranging from a high-end professional model dSLR to a compact point-and-shoot camera that's at least six years past its prime.

AN OATMEAL BOX CAN BE A CAMERA?

Curious about taking photos with an oatmeal box? Or think I'm making the whole thing up? Check out www.pinhole.org or www.pinholeday.org for galleries and more information than you ever dreamed of about pinhole cameras.

ABOUT THIS BOOK

This book is about redefining the relationship you have with your camera—from one that may be somewhat adversarial to one of respect and cooperation.

Though you may wish otherwise, this book is not a replacement for your camera's user guide. Seriously. It's not. So don't toss yours! (If you've already lost it, do a quick Google search or check the manufacturer's website to find a copy you can download. Or, if you prefer a hard copy, call the manufacturer to order one or check eBay.com.)

The camera's user guide is actually so important that I recommend you dig it out and have it on hand while you go through this book. (Seriously. You can go grab it now—I'll wait here.)

Carefully crafted to be applicable to any camera, anywhere, anytime, this book is meant to be a broad overview of how most cameras generally function. The exact way in which it applies to you and your camera will vary by model. If you have questions about locating a certain feature or menu option on your camera, you bet your sweet pixels I'll be referring you to your user guide for the answer. If you can make peace with that now, the rest will be easy!

Chapter 1 will give you a basic overview of some important terms and a broad understanding of the magic that happens every time you click the shutter, making it the best place to start, even if you plan to jump around to other chapters later. (For best results, I suggest that you read this book sequentially, as each chapter builds on the previously covered topics.)

Whether you have a dSLR, a pocket-size point-and-shoot camera, or something in between—sit back, relax, and read your way to triumphant photographic bliss (without the usual techno babble)!

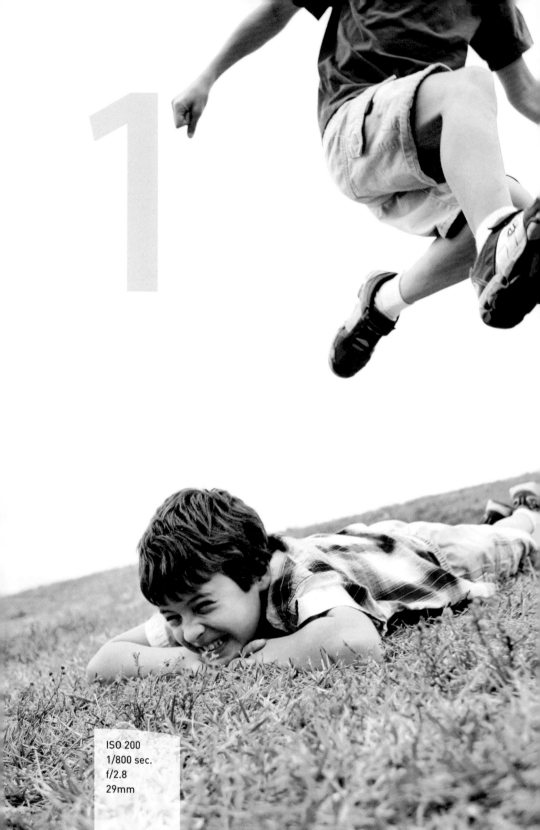

ISO 200
1/800 sec.
f/2.8
29mm

Three's Company

UNDERSTANDING SHUTTER SPEED, APERTURE, AND ISO

Remember that scene in *The Wizard of Oz* where Toto pulls back the green curtain and we all see that the man behind the "all powerful Oz" isn't nearly as scary as everyone thought? In fact, he turned out to be kind of sweet, even offering to fly Dorothy home in his hot air balloon.

Think of this chapter as your own look "behind the curtain." While you won't find a sparkling Emerald City, you will find your way to an understanding of the "magic" that happens with every photo you take.

1

PORING OVER THE PICTURE

On my way home one evening, I came across this scene along the side of a Nebraska highway and decided to pull over—the combination of the setting sun and the tall prairie grass was too much to resist! Happily, I happened to have my camera with me and was able to take advantage of the moment.

The background appears blurred due to the wide open aperture of f/1.8.

In addition to creating a blurred background, a wide open aperture also blurs the foreground.

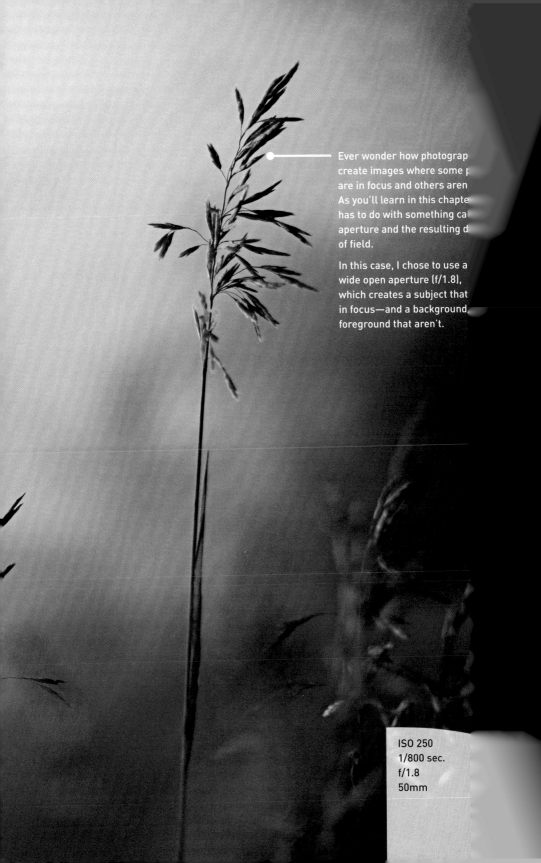

Ever wonder how photograp
create images where some p
are in focus and others aren
As you'll learn in this chapte
has to do with something ca
aperture and the resulting d
of field.

In this case, I chose to use a
wide open aperture (f/1.8),
which creates a subject that
in focus—and a background,
foreground that aren't.

ISO 250
1/800 sec.
f/1.8
50mm

A SIMPLE PRESS OF THE BUTTON

A lot of things happen in an instant when you press the shutter button and they all directly impact the resulting photo—whether it pleasantly surprises you, is just what you were expecting, or leaves you shaking your head and aiming to try again. A little bit of understanding goes a long way toward helping you get the results you want (without requiring a Ph.D. in camera technology, thankfully). As sophisticated as today's cameras are, in many ways they're actually still quite simple. So don't let the bells, whistles, and mountains of megapixels fool you. The mechanics of photography haven't changed and are simpler than you'd think—I promise!

Every photo you take is the direct result of the combination of three things known as shutter speed, aperture, and ISO (**Figure 1.1**). Each one controls a single aspect of how the resulting image will look.

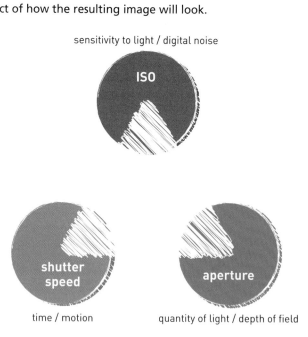

FIGURE 1.1
This is the ever-famous "exposure triangle." It represents the way shutter speed, aperture, and ISO come together to create an exposure.

You may be relieved to know that there's no right or wrong answer when it comes to how to combine these three variables—as long as you get an exposure (aka: picture) you're happy with.

To understand how **Figures 1.2** and **1.3**, captured only moments apart, can be made to look different from each other, we need to get on a first-name basis with each of the three variables.

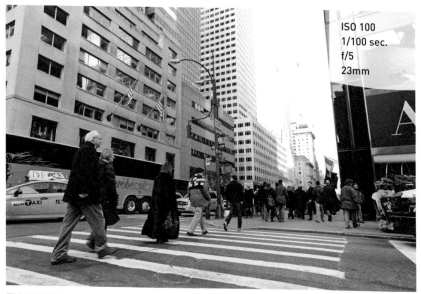

ISO 100
1/100 sec.
f/5
23mm

FIGURE 1.2
The movement in this scene appears crisp, as if frozen in time.

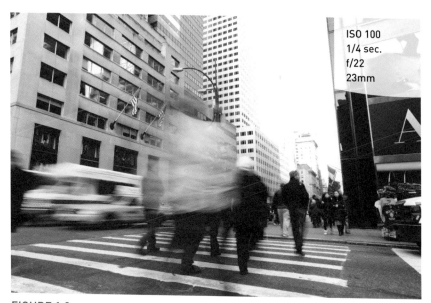

ISO 100
1/4 sec.
f/22
23mm

FIGURE 1.3
Here, the movement in the scene is blurred, conveying a sense of motion.

SHUTTER SPEED

Shutter speed controls time and motion, and how much of it gets recorded in a single photo.

If we compare a camera to the human eye, the shutter would be the equivalent of your eyelid. The shutter—which can open and close in a fraction of a second, or much slower—is directly responsible for the incredible images you've seen of blurred waterfalls and streaked car lights as well as pictures of exploding balloons and your favorite sports hero, frozen in time.

Typically measured in fractions of a second, the shutter speed controls the length of time light is allowed to access the camera's sensor (where the image is actually captured). In other words, it controls how long the camera's eye is open, so to speak. For example, a shutter speed of 1/500th of a second means that when you take a picture, the shutter will be open and the camera will be recording (exposing) for exactly 1/500th of a second.

Minimum and maximum shutter speeds vary, and may range from as fast as 1/8000th of a second to as slow as several seconds or even hours. Some cameras also include a shutter speed setting called "bulb," where the shutter will stay open for as long as you continue to hold the shutter down. Neato! **Figure 1.4** shows the relationship between shutter speed and time.

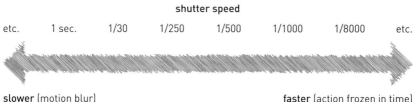

shutter speed

| etc. | 1 sec. | 1/30 | 1/250 | 1/500 | 1/1000 | 1/8000 | etc. |

slower (motion blur) **faster** (action frozen in time)

FIGURE 1.4
Measured in fractions of a second, faster shutter speeds freeze action, whereas slower shutter speeds allow for the creative use of motion blur.

Slower shutter speeds result in moving objects being recorded as blurry streaks—so if you want to convey movement or the passing of time in a photo, you choose a slower shutter speed. How slow? The answer depends on what you're shooting, and how blurred you want it to be. The only way to know for sure is to experiment. You might start with a shutter speed of 1/15th, and later discover through trial and error that you prefer the effects of a full four-second exposure, or something even longer! **Figure 1.5** shows some of the fun to be had with slower shutter speeds. Depending on how slow you go, you may require the use of a tripod, as shown in **Figure 1.6**.

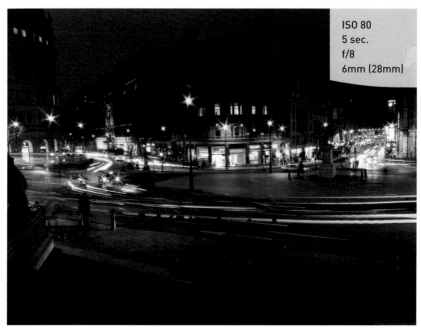

ISO 80
5 sec.
f/8
6mm (28mm)

FIGURE 1.5
A slow shutter speed of five seconds made it possible to capture passing vehicles as blurred streaks of taillights. (Note: The slow shutter speed of five seconds required the use of a tripod to stabilize the camera and prevent camera shake.)

FIGURE 1.6
I keep this tripod in my purse for occasions when I might want to shoot with slower shutter speeds. It's the GorillaPod from Joby (www. joby.com) and it makes an awesome addition to any equipment arsenal. Its legs can stand straight like a traditional tripod, or you can wrap them around objects (poles, posts, rails, and the like) to get the shot you want.

Conversely, faster shutter speeds allow you to seemingly stop time by freezing your subjects, as in **Figure 1.7**. Whether trying to capture your two-year-old toddler, your daughter's basketball game, or anything else on the move, a faster shutter speed makes it possible. How fast exactly? Well, just as before, it depends. You'll need to consider how fast your subject is moving and then—experiment!

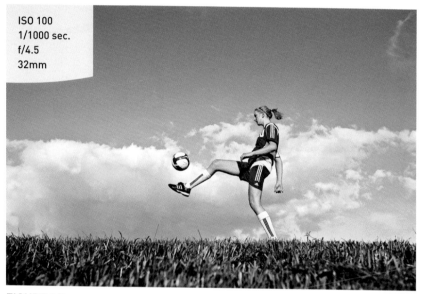

ISO 100
1/1000 sec.
f/4.5
32mm

FIGURE 1.7
To freeze the soccer player and ball in action, a faster shutter speed of 1/1000 was used.

APERTURE

The aperture controls the amount of light that passes through the lens, as well as something called "depth of field."

As long as we're comparing cameras to human eyes, we might also say that the aperture is akin to your pupil. Just as your pupil dilates or constricts in response to different lighting conditions, aperture is an opening inside your lens that can be set wide to let in more light, or closed down to let in less light.

Measured in something called "f-stops," aperture controls how much light is allowed to pass through the camera lens on its way to the sensor. In darker shooting conditions, the aperture might be opened wider to allow more light to reach the sensor, while brighter lighting environments may require the aperture to be closed down to keep light out.

Unlike shutter speed, which relates to the camera body itself, aperture is a
function of the lens. Therefore, the f-stop range available to you will vary
from one lens to the next (**Figure 1.8**).

aperture openings (not drawn to scale)

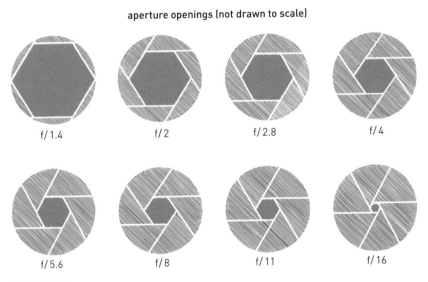

f/1.4	f/2	f/2.8	f/4
f/5.6	f/8	f/11	f/16

FIGURE 1.8

Here's a representation of various f-stop opening sizes as they range from f/1.4 to f/16.
Note that f/16 has a smaller opening than f/1.4, even though 16 is a larger number than
1.4. The *larger* numbers let in *less* light.

Because aperture values are really fractions (for the curious minds out there, the formula is focal length divided by effective diameter), the smaller numbers are actually wider openings than the bigger numbers. Thus, a setting of f/2.8 is wider and lets in more light than f/11 does.

APERTURE COMES WITH AN ADDED BONUS

Not only does aperture control how much light passes through the lens, but it also has the power to direct the viewer's attention by controlling something called "depth of field."

Depth of field refers to the size of the range of focus within a given image (**Figure 1.9**).

- **Deep:** A *deep* depth of field ensures that both the foreground (the area in *front* of your subject) and background (the area *behind* your subject) will appear in focus, whereas a *shallow* depth of field makes it possible for the subject to be in focus while the foreground and background are not.

- **Shallow:** Wider aperture openings (smaller numbers like f/3.5 or f/4), therefore, not only let in more light, but they also create a *shallower depth of field,* resulting in a blurrier foreground/background.

Conversely, narrower aperture openings (larger numbers such as f/16 or f/22) reduce the quantity of light while creating a deeper depth of field, allowing more of the foreground and background to be in focus (**Figure 1.10**).

In **Figure 1.11**, you can literally see the shallow depth of field appearing as a small strip of focus running across the focal plane of the frame. The image becomes blurred as it moves in either direction away from the focal plane.

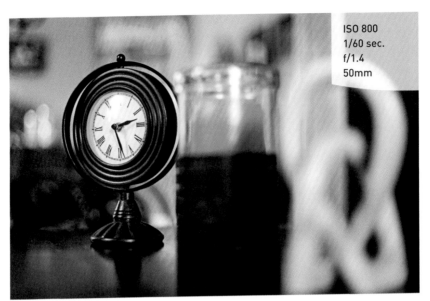

ISO 800
1/60 sec.
f/1.4
50mm

FIGURE 1.9
An extremely wide aperture of f/1.4 causes the image to become blurrier as the distance from the subject (the clock) increases in either direction (away from or toward the camera).

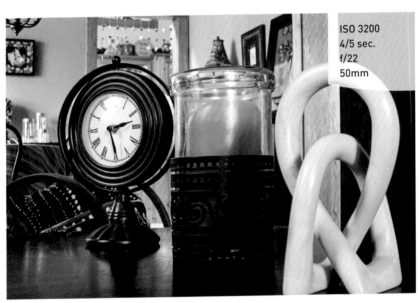

ISO 3200
4/5 sec.
f/22
50mm

FIGURE 1.10
An aperture of f/22 brings more of the background and foreground info focus.

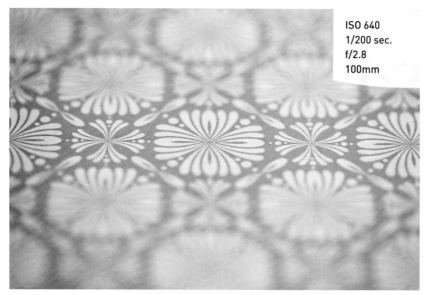

ISO 640
1/200 sec.
f/2.8
100mm

FIGURE 1.11

This is a close-up (macro) shot of a small stationery box I keep on my desk. The decorative pattern makes it easy to see where the shallow focal plane cuts across the frame.

Figure 1.12 will help you begin to wrap your mind around the idea that your f-stop setting controls not only the quantity of light, but also the depth of field.

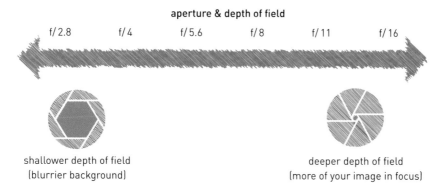

aperture & depth of field

f/2.8 f/4 f/5.6 f/8 f/11 f/16

shallower depth of field deeper depth of field
(blurrier background) (more of your image in focus)

FIGURE 1.12

Your effective depth of field is the result of your chosen f-stop setting combined with other factors, including the focal length of your lens and the distance between you and the subject.

To help you remember and make sense of all this, just ask yourself this question: When you're in your car driving down the highway, and you attempt to read a sign far off in the distance, what do you do?

You squint. We instinctively try to expand our focal range by literally making our eyes smaller (not sure if it really helps you read the road sign, but it does make a really great analogy!). Aperture works the same way. The smaller the opening, the bigger the focal range, and vice versa.

No one said this has to be complicated!

ISO

ISO controls the camera's sensitivity to light. It's the digital equivalent of film speed.

Back in the day, we bought different rolls of film for different kinds of shooting situations. For most people, this meant a last-minute trip to the drugstore only to end up standing in the checkout aisle confused about which box to buy. Should you get 800 or 200 speed? 24 exposures or 36? Such decisions! And whatever you bought, you were stuck with it until you finished the roll.

The pictures on the boxes were somewhat helpful in helping folks decide which film to buy. Sunny outdoor pictures graced the boxes of 200 speed film to let us know it was a good choice for bright/outdoor scenes, while indoor pictures of candlelit birthday parties reminded us that 800 speed film was for low light or indoor situations. Most people were just happy to have picked something—anything—even if they didn't always know what it meant. At least they could get out of the store and on with their lives!

Thankfully, we no longer need to stand in the drugstore, scratching our heads in a quandary about which film to purchase, nor do we need to finish a whole roll before switching to something that might be more appropriate for a given shooting situation. With digital, you can change the ISO from one photo to the next.

The available ISO range varies from camera to camera, but a typical example might range from 100 to 1600 or higher (**Figure 1.13**). The higher the number, the more sensitive the camera's sensor becomes. Thus, a low setting such as ISO 100 will require more light to make a photo than a higher setting such as ISO 1600 would.

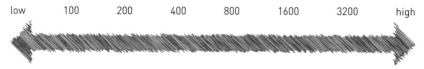

low 100 200 400 800 1600 3200 high

less sensitive
(less noise, for use in brighter situations)

more sensitive
(more noise, for use in low-light situations)

FIGURE 1.13

Available ISO capabilities vary from camera to camera, but they generally range from low (100) to 1600, 3200, and higher. The lower the number, the less sensitive the sensor is to light, whereas the higher the number, the more sensitive the sensor becomes, making it possible to make a photograph with less available light.

While every situation is different and the possible combinations for ISO, shutter speed, and aperture are too numerous to list, it's nice to at least have a loose reference point.

- **Low/100–200 ISO:** Bright, sunny, or otherwise well-lit environment.

- **200–800 ISO:** Indoors or outdoors with less light (very cloudy, in the shade, twilight hours, and so on).

- **800+ ISO:** Low-light situations where it's considerably darker.

ISO ON YOUR CAMERA

While many cameras offer ISO options similar to traditional film speeds, some models may only give you the option for low or high ISO. Additionally, some models may include settings called something like H1 (typically representing a generic high-level ISO) and possibly H2 (representing a higher-level ISO). As every make and model tends to vary, it's impossible to include an exhaustive list of possibilities here. Check your user guide if you're not sure where to find your camera's ISO or how to decipher the meaning of any additional options.

Just like high-speed film, high ISO settings have a drawback you may already be familiar with—digital noise. Aka, gunk or "rubbish," as our British friends might say (**Figure 1.14**). It's the digital equivalent of film grain, only somewhat less romantic. The problem has been dramatically reduced over the years and continues to improve, but it is still noticeable and worth consideration.

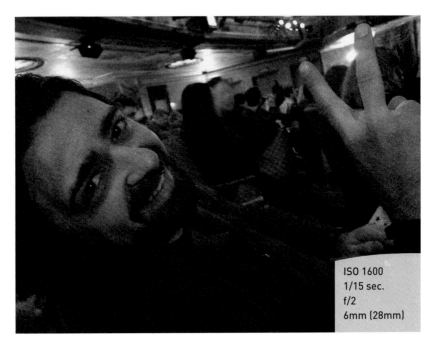

ISO 1600
1/15 sec.
f/2
6mm (28mm)

FIGURE 1.14
Taken in the darkness of a Broadway theater, this photo illustrates the effects of digital
noise (exaggerated a tad here to make it easier to see).

For this reason, shooting with a high ISO setting (1000+) is typically a last
resort, used only when all other combinations of shutter speed and aperture
have been exhausted. If your shutter speed is as slow as can be without a
tripod, and your aperture is as wide open as the lens is capable of being (or
as wide as your desired depth of field demands), and you still aren't able to
achieve a decent exposure, then it makes sense to reach for a higher ISO. But
generally, it's not where you want to start.

ISO RESTRICTIONS

Many cameras have a restriction for ISO that limits how high your camera is allowed to "reach" when attempting to increase ISO for a proper exposure. This feature is sometimes referred to as "expanded" or "high" ISO, and it prevents you from unintentionally shooting at very high ISO settings. Don't like being restricted? Dig around in your settings to remove the limitation. Note: The option to remove the restriction is likely found within a "general settings" menu. It's not necessarily in the same place where you select your specific ISO settings.

PUTTING IT ALL TOGETHER

Regardless of whether you prefer to let the camera handle all the decision making (auto mode) or if you like calling your own shots (manual mode), it's all just a triangular-shaped balancing act. Now that you understand the variables, revisit the infamous exposure triangle shown in Figure 1.1.

The overall objective is a pretty simple one—to create something that is, to you, an ideal exposure. Whether the camera does it for you, or you take control by selecting your own shutter speed, aperture, and/or ISO, balance is the key. A shift to one part of the equation will require an adjustment to the other two settings. There's no right or wrong way to combine the three variables—as long as you get the results you want.

The good news is that there are all different kinds of shooting modes that facilitate this process, giving you a choice as to how the variables are combined and how much control you want to keep for yourself, or turn over to the camera.

Are you starting to feel the love? Onward to Chapter 2!

Chapter 1 Assignments

Seeing the Exposure Triangle

The unique combination of three things is responsible for creating the exposure of your image: shutter speed, aperture, and ISO. Take a look at some images you've shot with your camera and examine what shutter speed, aperture, and ISO were used for each shot. See if you can start to "see" how the exposure triangle works in each image, and how each element affects the look of your shot:

• Shutter speed controls time and motion.

• Aperture controls quantity of light and depth of field.

• ISO is how sensitive your camera's sensor is to light.

There's no right or wrong way to combine all these variables, as long as you get the exposure that you want.

Share your results with the book's Flickr group!

Join the group here: flickr.com/groups/gettingstartedfromsnapshotstogreatshots

2

ISO 80
1/125 sec.
f/8
6mm (28mm)

Shooting Mode Bonanza

GETTING BOSSY, AND LEARNING TO LIKE IT

If the alphabet soup of shooting modes and dizzying collection of scenes (or presets) your camera offers has ever felt overwhelming, you are not alone. It's largely the reason so many people's cameras spend most of their lives in auto mode, never getting to live up to their full potential. How sad!

But—there's a world of goodness (not to mention better photos!) awaiting you if you're open to it. You may even let go of auto mode altogether once you try some of the other options (seriously!).

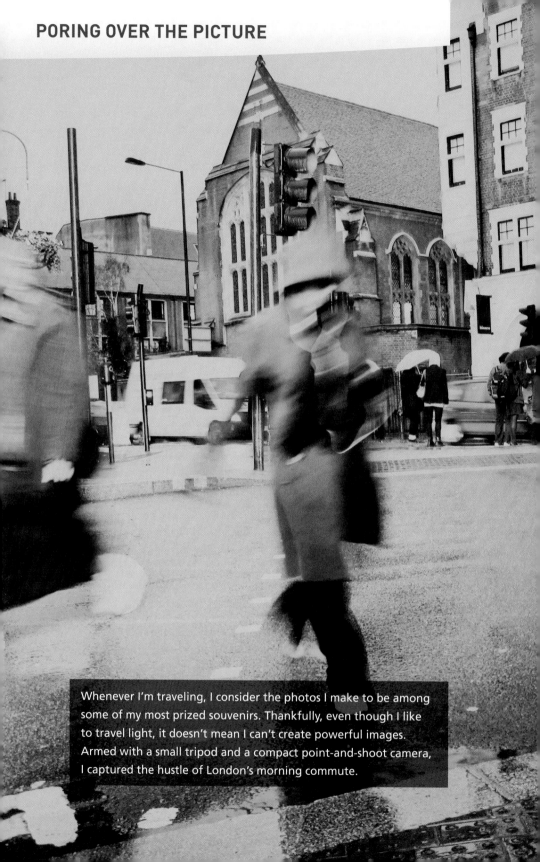

PORING OVER THE PICTURE

Whenever I'm traveling, I consider the photos I make to be among some of my most prized souvenirs. Thankfully, even though I like to travel light, it doesn't mean I can't create powerful images. Armed with a small tripod and a compact point-and-shoot camera, I captured the hustle of London's morning commute.

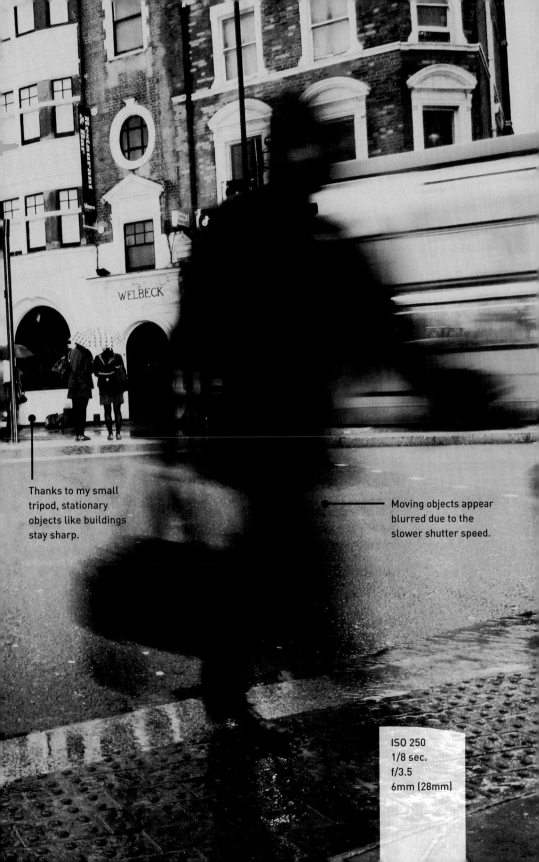

WELBECK

Thanks to my small tripod, stationary objects like buildings stay sharp.

Moving objects appear blurred due to the slower shutter speed.

ISO 250
1/8 sec.
f/3.5
6mm (28mm)

THE CONTINUUM OF CONTROL

The shooting modes represent what I like to refer to as a "continuum of control" as seen in **Figure 2.1**. On one end of the spectrum is auto mode, in which the camera is the boss and you have pretty much zero control. The other end of the spectrum is home to manual mode, offering you full executive power and complete control over every image.

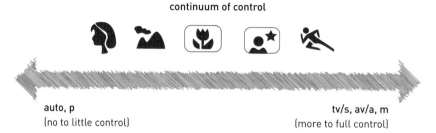

continuum of control

auto, p
(no to little control)

tv/s, av/a, m
(more to full control)

FIGURE 2.1
Modes on the left, such as auto, give you little to no control over camera settings, whereas modes on the right, such as Tv/S, Av/A, or M, give you greater amounts of control. Specialty modes or scenes generally fall somewhere in between.

Specialty modes and scenes tend to fall somewhere in between.

In most dSLRs, shooting modes are commonly found on a round dial on top of the camera, as in **Figure 2.2**.

FIGURE 2.2
The available shooting modes on a dSLR camera are usually found on a dial like this, located on top of the camera.

A point-and-shoot camera might have a similar dial (**Figure 2.3**) or a more limited slider bar (**Figure 2.4**) on the top with additional options within your menu system. It's also possible that some point-and-shoot camera models don't offer shooting modes, providing scene presets instead (explained later in this chapter).

I suggest taking a moment to locate each one as we go through them. As always, if you get lost, cozy up with your user guide.

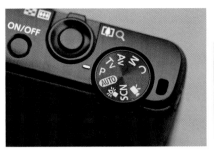

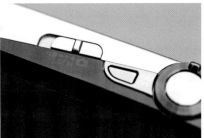

FIGURE 2.3

Some point-and-shoot cameras that offer expanded controls (such as Canon's Powershot G or S series) feature a dial that's similar to what you would find on a dSLR.

FIGURE 2.4

Though most point-and-shoot cameras offer a more limited range of shooting modes, you'll typically find a selection of helpful presets to accommodate various shooting situations from within your camera's scene menu.

AUTOMATED MODES

The first two modes on the far left of the continuum (Figure 2.1) take the guesswork out of photography, making it quick and easy to get a shot—and get on with your life.

AUTO MODE (A)

This is home base for most people—and not without reason. It's comfortable, it doesn't require any thinking, and although the results might often be unpredictable or disappointing, you can always just blame the camera, right? Not anymore! You'll learn how to take responsibility for your images as we move through this book.

In auto mode, the camera is in the driver's seat and gets free reign regarding all decision-making—and it is certainly not interested in any input from you. Need to change your white balance? Don't even think about it. Did the camera misjudge the exposure? Too bad. Feel like you need to add some fill flash? Think again. (Don't have a clue what white balance or fill flash is? Don't worry—you'll learn all about it in Chapter 3. For now, just know that auto mode is pretty restrictive and doesn't give you many, if any, options for tweaking settings.)

In fact, some functions may even appear to be entirely missing from your camera when set to auto mode. So if you're trying to find your white balance settings and are nearly convinced your camera doesn't have it, don't give up. Those settings are likely there. Many cameras simply declare them off limits in auto mode.

SUCCESS IS HARDLY "AUTOMATIC," NO MATTER THE CAMERA

Some folks think that having a big fancy dSLR means that auto mode is somehow better than it would be on a less expensive model or a point and shoot. The truth is, it's not—and not by a long shot.

Take a look at **Figures 2.5–2.7**. The first two images were shot with a professional dSLR, a pro lens, and a pro hot-shoe flash (an external flash mounted to the top of the camera) for a total cost of just under $5,000. *One* was captured with the camera (and the flash) set to auto mode (yuck!), while the other was shot with the same fancy gear, using a different mode that offers more control.

Still not convinced? Even a simple programmable mode on my older model point and shoot beats auto mode on my fancy dSLR! Have a look at the final shot of the same scene, captured on a camera that cost less than $400.

Auto mode is still just auto mode—even on a fancy camera.

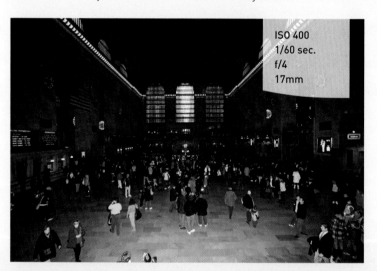

ISO 400
1/60 sec.
f/4
17mm

FIGURE 2.5

Captured in auto mode on professional equipment (with an apparently very dirty lens!), this photo was horribly expensive considering the cost of the professional gear used to create it. All that gear (about $5,000 worth) and the photo still looks horrifically bad. That's auto mode for ya!

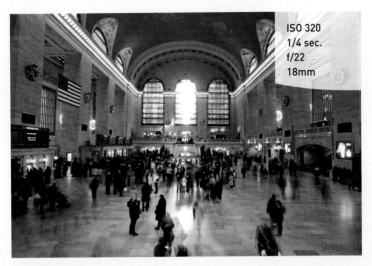

ISO 320
1/4 sec.
f/22
18mm

FIGURE 2.6

Using the same professional gear in a different shooting mode that offers more control than auto, I was able to cancel the flash, choose a slower shutter speed, and get a much higher-quality shot.

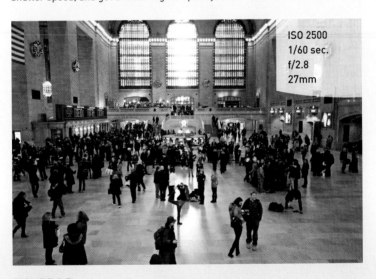

ISO 2500
1/60 sec.
f/2.8
27mm

FIGURE 2.7

This one is straight from my older model point-and-shoot camera. In a programmable mode, I simply canceled the flash and gave the camera permission to access the higher range ISO settings to compensate for not using the flash. Simple! (And much, much less expensive!)

PROGRAM MODE (P)

This setting is similar to auto mode, but without the handcuffs. The camera still makes the decisions regarding shutter speed, aperture, and ISO—but you're free to chime in with suggestions on settings such as white balance, exposure compensation, and flash settings (explained in Chapter 3).

It's practically paradise for the auto mode converts out there (maybe that's what the "P" should stand for—paradise!). If your camera supports this option, it's definitely worth warming up to. **Figure 2.8** and **Figure 2.9** are great examples of how easy it can be to get wonderful images from program mode.

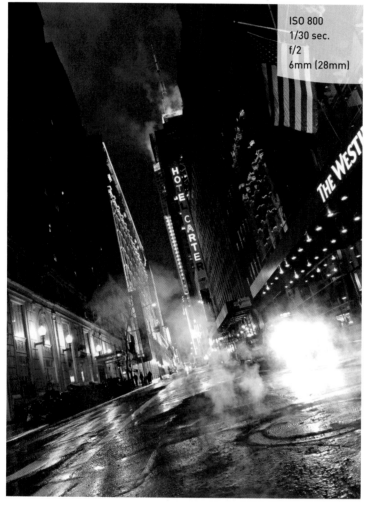

ISO 800
1/30 sec.
f/2
6mm (28mm)

FIGURE 2.8
By selecting program mode on my point-and-shoot camera, I was able to cancel the flash that would've otherwise ruined the shots.

ISO 400
1/60 sec.
f/2
6mm (28mm)

FIGURE 2.9

Another image made possible by selecting my point and shoot's program mode and canceling the flash.

CREATIVE AUTO (CA) MODE

Some camera models also include a mode called Creative Auto (CA) that splits the difference between auto and program modes. If you're super curious, your user guide can fill you in on the details.

SPECIALTY MODES

This next cluster of modes is sometimes found on the dial next to auto and program modes, while other times the specialty modes are tucked in with your camera's "scene" options. Every camera model is different, so keep yours (and your user guide) on hand to locate the modes (or scenes) as we go.

PORTRAIT MODE

Traditional portraiture uses wide apertures to make the background appear slightly blurred, directing the viewer's attention to the subject in the foreground. As you read in Chapter 1, this is known as a shallow depth of field.

When you select "portrait" mode, you're telling the camera that you're about to take a close-up photo of a person (**Figure 2.10**) and that you'd like to separate them from the background with a shallow depth of field.

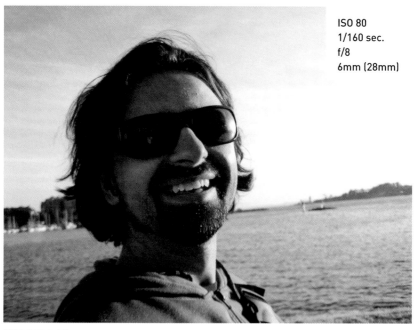

ISO 80
1/160 sec.
f/8
6mm (28mm)

FIGURE 2.10
My husband, Emir, making our point and shoot's portrait mode look good!

The camera takes a stab at this by prioritizing the exposure for a wider aperture. Of course, exactly how blurred the background will be also depends on lighting conditions, your lens, and the distance between you and your subject. (Blurred backgrounds are even more dramatic when you're close to your subject—so don't be afraid to get closer!)

Additionally, since portraiture generally involves taking photos of people, it's important that the color in such images be handled with care to produce what's known as pleasing skin tones. Portrait mode facilitates this by optimizing saturation, brightness, and contrast with this goal in mind.

LANDSCAPE MODE

Contrary to what you may think when looking at the icon, you don't have to live in a mountain state to make use of landscape mode! Essentially the opposite of portrait mode, this setting tells the camera that—unlike a portrait with a blurry background—you'd prefer more of your image in focus. The camera responds with a smaller aperture for greater depth of field. Just as portrait mode places an emphasis on great color for skin tones, landscape mode puts an emphasis on rendering color for great-looking foliage and skies (**Figure 2.11**).

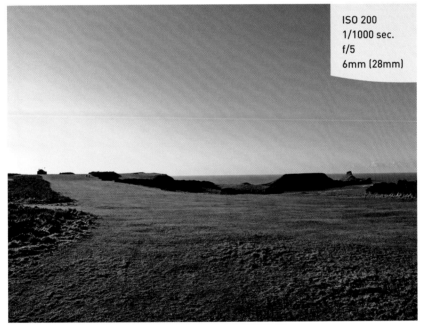

ISO 200
1/1000 sec.
f/5
6mm (28mm)

FIGURE 2.11
The beautiful green coast of Wales captured with a point-and-shoot camera.

SPORTS MODE

Similar to what some cameras also call "kids & pets" mode, "sports" mode tells the camera you're about to photograph a moving target. The camera responds by making a faster shutter speed the priority and employing a special focusing mode (usually called "servo" or "continuous" focusing) that allows you to track moving targets (**Figure 2.12**).

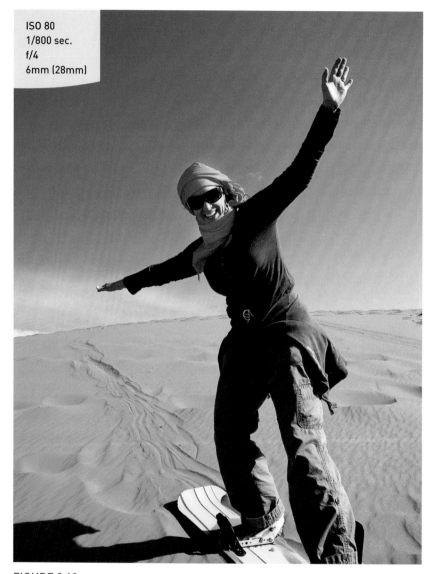

ISO 80
1/800 sec.
f/4
6mm (28mm)

FIGURE 2.12
Emir used our point-and-shoot camera to capture this image of yours truly sand boarding in Morocco's Sahara Desert.

Additionally, some cameras might include a drive shift into what's known as "burst mode," enabling you to shoot several frames in rapid succession (discussed further in Chapter 3). All this, and you still don't have to worry about setting your own exposure!

MACRO MODE

Macro mode is a bit of a trickster, appearing in a number of different places on different cameras—sometimes on the dial along with everything else we've talked about so far, sometimes within a menu, and sometimes it gets its very own button on the back. If you can't easily find yours, check your user guide.

Macro mode enables your camera to focus on objects very close to your lens as in **Figure 2.13**, making it possible to capture close-up imagery in a way not possible in other modes.

Since you're working at such a close distance, you may find that it works best to turn off your flash while shooting in this mode. Experiment to see what you like best.

ISO 80
1/100 sec.
f/2.8
6mm (28mm)

FIGURE 2.13
This image was captured with the macro mode on my super ancient point-and-shoot camera—and it looks great!

NIGHT PORTRAIT MODE

This shooting mode is a bit of a wild card, because although nearly every camera offers it, it's tricky to say where you'll find it. Some cameras include it alongside all the other shooting modes we just talked about, others consider it a "scene" (explained later in this chapter), and others still tuck this feature in with the flash functions (explained in Chapter 3), referring to it as "slow-sync" or "night" flash.

In a nutshell, this mode combines flash exposure with a slower shutter speed in an effort to balance your brightly lit subject (illuminated by your flash) with the background that might otherwise look like a dark cave in comparison, as seen in **Figures 2.14** and **2.15**. It may not always be a miracle worker, but it is nice to have around.

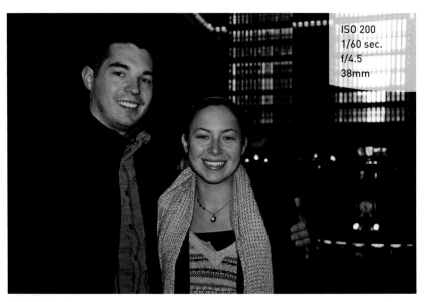

ISO 200
1/60 sec.
f/4.5
38mm

FIGURE 2.14
While visiting New York City's Grand Central Station, this adorable couple handed me their dSLR and asked if I would take their photo. (They were then kind enough to email it to me to include in this book—thanks, guys!) I shot this one in auto mode, and you'll notice that although Lauren and Brandon look great, the background is a dark abyss.

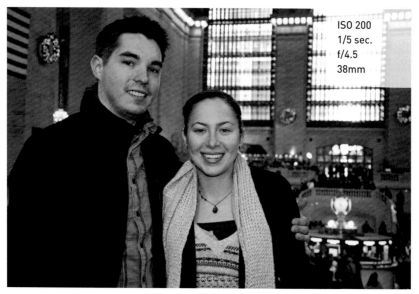

ISO 200
1/5 sec.
f/4.5
38mm

FIGURE 2.15

I switched the flash to their dSLR's version of night portrait mode, instructing the camera to use a much slower shutter speed. This gave the dark background (not lit by the flash) time to be recorded and actually show up in the finished photo. Much better!

SCENE MODES

Similar to the shooting modes we just discussed, "scenes" help you fine-tune some additional camera settings by providing a variety of presets for situations or scenes you might find yourself in. Whether you're building a snowman, celebrating the Fourth of July, treasure hunting underwater, photographing kids on the run, relaxing at the beach, or throwing a birthday party, there's probably a scene preset to help you out. In some cases, scenes are found on your camera's mode dial, whereas other models store them within the camera's menu system.

You can probably find a scene to match just about any condition you may find yourself shooting in. The key is to experiment—so take test shots ahead of time. Don't wait until the exact moment little Suzy is about to blow out her birthday candles to discover that you get better results from "party" scene than "night portrait" scene!

You might also discover that your camera offers a wide selection of "special-effect scenes" that mimic fish-eye or tilt-shift lenses (**Figures 2.16** and **2.17**), allow you to shoot in black and white, or help you capture photos to stitch into a panorama later on the computer.

Although most shooting modes (except for auto) let you adjust settings such as white balance and exposure compensation (explained in Chapter 3), the freedoms you have while shooting with a scene preset may be somewhat restricted and can vary from scene to scene and camera to camera. You may be giving up some control in exchange for a generalized preset recipe for a specific shooting condition. As in life, there's some give and take.

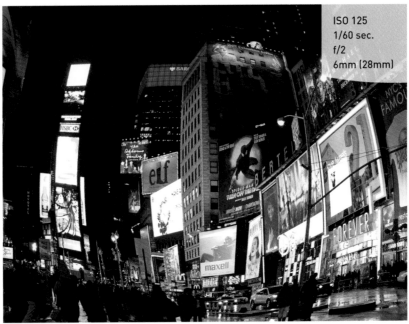

ISO 125
1/60 sec.
f/2
6mm (28mm)

FIGURE 2.16
Times Square rendered with the fish-eye effect from my point and shoot's scene menu.

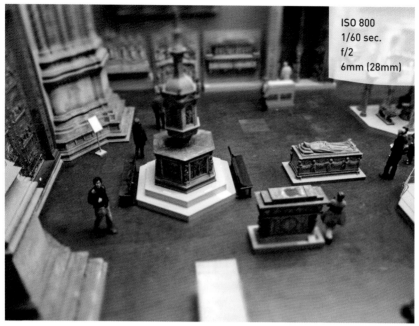

ISO 800
1/60 sec.
f/2
6mm (28mm)

FIGURE 2.17
Captured using my point and shoot's tilt-shift effect, this setting makes things appear as if they were very tiny and is therefore also referred to as the "miniature effect."

PRIORITY MODES

At some point, you may find yourself wanting more control over your exposure settings. While scenes and presets can be hugely advantageous, they're still limiting in the sense that the camera is still in the driver's seat, dictating the specifics of shutter speed, aperture, and ISO.

PRIORITY MODES AND POINT-AND-SHOOT CAMERAS

Most point-and-shoot cameras don't offer priority or manual shooting modes, but more and more compact models are starting to—so check your user guide to find out for sure. And even if you discover your current camera falls short when it comes to offering these options, don't quit reading—study up to know what you want to look for when you're ready to expand your options.

In certain situations, you'll want to take over the controls and make your camera the copilot—ready to take orders from you for a change! If this sounds exciting, but the idea of jumping to full-blown manual mode is too much to chew on, these next two modes may really float your boat.

Put on your captain's hat—it's time to get bossy!

SHUTTER PRIORITY (TV OR S)

This mode has nothing to do with hooking your camera up to the latest high-def big screen television (as the abbreviation on the dial may lead you to believe), and everything to do with you rolling up your sleeves and flexing your photo know-how!

THE LOWDOWN ON DSLRS VS. POINT-AND-SHOOT CAMERAS

I firmly believe that any camera can be a great camera, whether it's an inexpensive point and shoot or a professional-level dSLR, as long as:

1. It's with you, and

2. You fully understand how to use it.

That said, just as there's a difference between a hammer and a nail gun, there are differences between a point and shoot and a dSLR that are worth considering, one of which is the ease of taking control of settings like shutter speed and aperture.

Though priority modes may not be an option on most point-and-shoot cameras, some models, such as Canon's Powershot G and Powershot S series, are out to change that. They combine the compactness of a point and shoot with the advanced control options, like priority and manual modes, typically found only on dSLRs. Is it the best of both worlds? Perhaps!

Shutter priority mode allows you to set your own shutter speed while leaving the rest up to the camera. How awesome is that? Control without the head-ache! Plus, don't forget you still have access to options such as white balance and exposure compensation (explained in Chapter 3), making this mode pretty darn attractive, wouldn't you say? Additionally, while in this mode you may have the option of selecting auto for your ISO, or choosing a specific ISO in addition to choosing your shutter speed. Experiment or check your user guide to find out for sure.

On a dSLR, you usually set the shutter speed by turning a dial that looks something like what you see in **Figure 2.18**.

FIGURE 2.18
The front dial on a dSLR typically controls shutter speed.

SHUTTER PRIORITY'S ABBREVIATIONS: TV AND S

Some cameras refer to shutter priority mode with an (S). Others refer to it as (Tv), which stands for "time variable" since the shutter speed (which controls time) is the priority when shooting in this mode. All other exposure decisions are built around what you select for the shutter speed.

If you have a point-and-shoot camera that offers shutter priority mode, the control may be a dial on the back, a ring around the lens as pictured in **Figure 2.19**, or a setting within the file menu. As always, if you're not sure where to find something, pause for a moment and look it up in your camera's user guide.

FIGURE 2.19

This ring around the lens on my point and shoot controls the shutter speed when shooting in shutter priority mode.

TRY IT!

To get a feel for how this mode works and what your shutter is capable of, set your camera to shutter priority mode and pick a shutter speed like 1/125th, keeping in mind that your camera may simply display 125 instead of the fraction. How do you know which shutter speed you've selected? You'll see your current shutter speed—along with various other exposure information—on the screen when you look either through your viewfinder or at the back of your LCD screen.

As you move the camera around and aim the lens at different scenes of varying brightness levels, you'll notice that the shutter speed holds constant while the other settings fluctuate as the camera automatically adjusts the aperture (and possibly the ISO) in response to what's in front of the lens. This is the beauty of shutter priority mode. Pretty cool, huh?

Play with your shutter speed and see how fast it's capable of going—it might be able to reach speeds as fast as 1/4000th or even 1/8000th of a second! What about its slowest option? Depending on your camera model, your shutter might be capable of exposures as long as 15 or 30 seconds!

Shutter speeds of a full second or slower are usually expressed with double quotation marks. So while a shutter speed of 1/30th might appear on your screen as 1/30 or simply 30—a shutter speed of 30 full seconds would be displayed as 30".

HOW MIGHT YOU USE SHUTTER PRIORITY MODE IN REAL LIFE?

Imagine that you're on the adventure of a lifetime somewhere exciting in Africa. You're perched in a rooftop cafe enjoying the view while the market square below you is abuzz with activity.

You soak up the sights and sounds of motorbikes racing by, vendors selling everything from fresh fruit to henna tattoos, and musicians filling the air with the sounds of their African drums (**Figure 2.20**). Definitely a scene to remember!

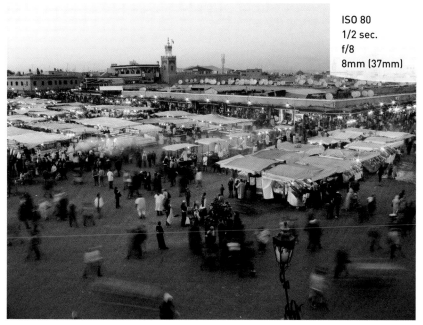

ISO 80
1/2 sec.
f/8
8mm (37mm)

FIGURE 2.20
Jemaa al Fna Square in Marrakech, Morocco.

Naturally, you reach for your camera and decide that, in an effort to convey the life and energy of the scene, you'd like to capture the movement of the people with a touch of motion blur. If you've read Chapter 1, you know it's the shutter speed that controls time and movement. And because you're reading this chapter, you know that of all the modes we've discussed thus far, shutter priority is the only one that lets you pick a shutter speed without having to worry about anything else. So for this situation, it's a great choice.

To blur the movement of the people, you'll need a slow shutter speed. Exactly how slow will ultimately depend on the light, how fast or slow your subjects are moving, and how blurred you want their movement to appear.

Anytime you plan to slow down your shutter to anything beyond 1/15th or even 1/30th, camera shake is a possibility. But don't panic if you didn't pack your tripod (who wants to drag that around on vacation?); just find a bench, ledge, or tabletop to set your camera on, and you'll be fine.

Make sure your flash is turned off and try setting the shutter speed to 1/15th of a second to start with. You have to start somewhere and 1/15th is literally just a guess. (I'll talk more about turning off the flash in Chapter 3; for now, just know that sometimes flash gets in the way, and we don't want it to interfere with the scene here.)

Steady the camera and press the shutter button. Check out the resulting photo. If the people aren't blurry enough for your liking, slow the shutter down even more (but not too slow or the people passing by might not show up at all). If you think the people are too blurry, pick a faster shutter speed. Go wild and experiment like crazy. Try a second, 8 seconds, or whatever your camera will allow. There's no right or wrong answer here, just whatever you like best. Isn't that reassuring?

Once you get the shot you were hoping for, switch the camera back to auto mode and take a photo. Isn't the difference astounding? Aren't you proud of yourself? Do something special with that image when you get back home. It's a true accomplishment—frame worthy for sure!

But what if you wanted to freeze the action instead? You would follow the same process, but you'd start with a faster shutter speed, maybe 1/250 or 1/500, and go from there. The more you play with these modes, the better you'll get at guessing, and the faster you'll arrive at an exposure that you like.

TIP FOR SHAKY PHOTOS

Still shaky? If you've steadied the camera on a ledge, bench, or tabletop and you're still getting a bit of camera shake in an image (which is quite common), try using your camera's self-timer function set to 2 seconds (see Chapter 3 for more details). By the time you press the button and let go, the camera will have stabilized again before taking the picture.

APERTURE PRIORITY (AV OR A)

As you might now imagine, aperture priority mode lets you set the aperture while the camera selects the shutter speed. Like shutter priority mode, aperture priority might also give you the option of either selecting auto for your ISO, or being able to choose your ISO in addition to choosing your aperture. Experiment or check your user guide to find out for sure.

On a dSLR, you typically adjust the aperture (in aperture priority mode) by turning the same dial you previously used to adjust shutter speed. The dial is often "mode dependent," meaning that it controls the variable of whichever shooting mode you're currently using. When you're in shutter priority mode, the dial controls the shutter; when you're in aperture priority mode, it controls the aperture. (This applies to the priority shooting modes only. If you're shooting in manual mode, aperture might be controlled in a different way. Check your user guide for details.)

TRY IT!

To see the beauty of this mode in action, take a look at your info screen (either through your viewfinder or on your LCD screen) and set your aperture to something like f/5.6 (typically displayed on your screen as just 5.6). As you did before, aim your camera at scenes with varying levels of brightness. You'll notice that while the aperture setting remains constant, the camera is continually adjusting the shutter speed (and possibly the ISO, depending on your camera model and the way you've configured your settings). Who says you can't have your cake and eat it, too?

How wide is the aperture of your lens capable of opening? As you play with the controls, you may find that it stops at f/5.6, f/4.5, or f/3.5. If you zoom your lens all the way out, you may discover you're able to open the aperture even wider. So while the aperture may have stopped at f/4.5 or f/5.6 when you were zoomed in closer, once you zoom all the way out, you may be able to open it as wide as f/3.5 or wider. (This phenomenon is explained further in Chapter 4.)

How small can your aperture setting go? Play with your settings and see for yourself. It may be as tiny as f/8, f/11, or even f/22!

HOW WOULD YOU USE APERTURE PRIORITY MODE IN REAL LIFE?

If you're in a situation in which you want to separate your subject from the background by using a shallow depth of field like in **Figure 2.21**, this mode is for you! Set your aperture to as wide open as your lens is capable of, come in as close to the subject as possible, and take the shot.

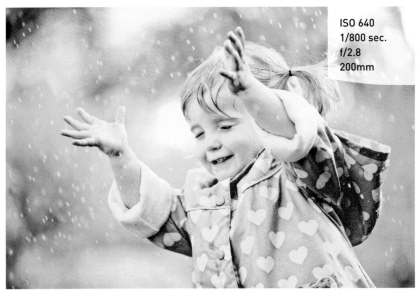

ISO 640
1/800 sec.
f/2.8
200mm

FIGURE 2.21
To make this cutie pop from the background, I created a shallow depth of field by selecting a wide aperture.

Conversely, if you're taking a group shot and want to make sure that everyone is in focus from the front row to the back, be sure that you don't use a wide aperture, or you may only get the people in the first row or so in focus. D'oh! In such a case, you might start with test shots set to an aperture of f/5.6 or f/8 and adjust as necessary.

BACKGROUND BOKEH

The resulting blurriness of the background (referred to as "bokeh") will be exaggerated the closer you are to your subject and the longer the focal length of your lens. Figure 2.21 was captured with a 200mm lens, resulting in an especially blurry background. (Don't know what focal length is? See Chapter 4 for details.)

It really is that easy! Again, the more you play with these modes, the easier they become and the faster you'll get.

FULL CONTROL

At times, letting the camera have any input at all may prove to be more of a hassle than it's worth. As the saying goes, when you want something done right, sometimes you just have to do it yourself!

MANUAL MODE (M)

When partial control just isn't cutting it, manual mode is the way to go—giving you full decision-making power over the shutter speed, aperture, and ISO for each and every shot.

Even if you don't foresee yourself shooting in manual mode on a regular basis, there are occasions when it may be literally the only way to get the image you want. Consider the following series of images captured on my point and shoot in the dark of night of Morocco's Sahara Desert. **Figure 2.22** was captured the way most people would've approached the scene—in auto mode (with auto flash). The result is a bright mound of sand, giving way to a black abyss. If I didn't know any better, I'd think we were in a black hole!

After studying the previous image and acknowledging the dark cavernous abyss beyond the range of the flash, you might think that night portrait mode (or night portrait scene) would be a better choice here, since it generally allows more of the background (the area not lit by the flash) to be recorded.

The result of night portrait mode is shown in **Figure 2.23**, where you'll notice that the camera made two exposure adjustments: the shutter speed slowed from 1/15th of a second to 1 second, and the ISO increased from 400 to 640. While night portrait mode was a nice attempt (if you look closely, you can see a bit more of the camels and clouds), it wasn't enough to make much of a difference.

If you've read ahead to Chapter 3, you may be thinking, "What about exposure compensation? Wouldn't that fix it?" I like the way you think! But—even though exposure compensation is incredibly handy (as you'll see later in Chapter 3)—in this example, we are so far off from a proper exposure that even something as great as exposure compensation can't save us.

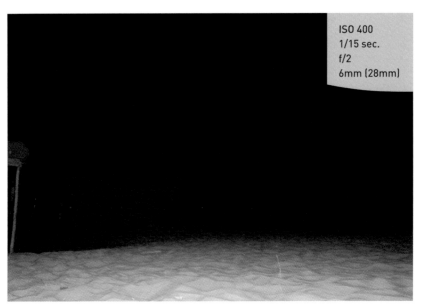

ISO 400
1/15 sec.
f/2
6mm (28mm)

FIGURE 2.22
Shot in auto mode, the camera chose all the settings, resulting in a brightly lit mound of sand surrounded by a huge black hole of—nothing.

ISO 640
1 sec.
f/2
6mm (28mm)

FIGURE 2.23
When auto mode fails in a situation like this, you might reach for night portrait mode next. While night portrait mode may be successful at a wedding reception or downtown somewhere with city lights behind you—here in the middle of the dark desert, it just wasn't enough.

Nope. I had only one choice—switch to manual mode.

Then—I canceled the flash. Since it's only capable of illuminating a limited distance (as opposed to lighting up the entire Sahara), it isn't helpful here.

Next, opening the aperture as wide as I could, I slowed down the shutter speed for the longest exposure my point-and-shoot camera was capable of and selected the lowest ISO I thought I could get away with (as you may recall from Chapter 1, higher ISOs result in images with a lot of digital noise).

In this situation, it was actually so dark out that I could barely see well enough to compose the scene, let alone find something to focus on. Thus, if you look carefully, the focus is actually on the sand rather than on the structures or camels as I would've liked it to be—but as soon as I pressed the shutter button, waited 15 seconds for the exposure, and eventually saw the result—I was in love!

Thanks to the full control of manual mode, I was able to capture a gorgeous rendering of the Sahara Desert (**Figure 2.24**) complete with two camels, twinkling stars, and the warm glow of our campfire (which could not be seen whatsoever in the previous two frames because the flash overpowered it).

But how do you know which settings to use? Keep reading to find out!

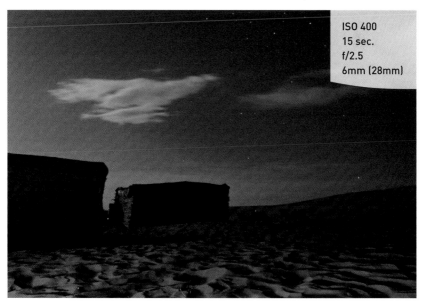

ISO 400
15 sec.
f/2.5
6mm (28mm)

FIGURE 2.24
Our view of the Sahara Desert as made possible with manual shooting mode.

GET TO KNOW YOUR LIGHT METER

It may seem like professional photographers routinely pull perfect exposure settings out of a magic hat—but it doesn't work quite that way. Over time, practice, experience, and ultimately trial and error will prove to be your best strategy (I literally guessed at the settings I used for the Sahara shot in Figure 2.24). But before you master the skills that come from practice, practice, and more practice, there is a tool made specifically for helping you choose the appropriate exposure settings. The good news? You already have it—it's built right into your camera. Ladies and gentlemen, I'd like to introduce you to—drum roll— your very own light meter (**Figure 2.25**)!

-2 . . -1 . . 0 . . +1 . . +2

FIGURE 2.25

Displayed when looking through your viewfinder or at the back of your LCD screen, some light meters are horizontal like this one, whereas others are displayed vertically.

Light meters work by measuring the light in any given scene and predicting what the exposure will look like based on the camera's current settings. You'll find the light meter when looking through your viewfinder (or possibly at your LCD screen). They vary from camera to camera, so while the meter in Figure 2.25 is displayed horizontally, yours might run up and down instead. Some meters include numbers as shown with the meter in Figure 2.25, while others just show dashes or tick marks with no numbers whatsoever. If you have a hard time locating the meter on your camera, check your user guide for details.

The value of the light meter is that it dynamically adjusts based on the light it reads coming from the scene in front of the lens—and how your current camera settings relate. If you remember back to Chapter 1, you learned that light is measured in something called stops. If you look closely, you'll notice that even if your meter doesn't include numbers, it displays an exposure range stretching from two stops underexposed (–2) to two stops overexposed (+2), typically in increments of 1/3 of a stop.

The further away your current camera settings are from what the meter thinks they should be, the further to either side of center (0) the indicator will go. Thus, when the camera thinks the picture will be too dark (underexposed), the indicator will be displayed on the minus (–) side, as in **Figure 2.26**.

And as you would expect, if the camera thinks your photo will be too bright (overexposed), the indicator will be displayed on the plus (+) side, as in **Figure 2.27**. Again, the further toward the + side the indicator is, the brighter the camera believes the exposure will be.

Of course, it's no surprise that when you've made the meter happy, the indicator will hover around the center (0), letting you know that the camera believes you've found the magical combination of settings that will make for a properly exposed image (**Figure 2.28**).

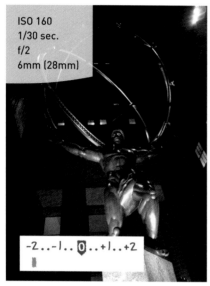

ISO 160
1/30 sec.
f/2
6mm (28mm)

-2..-I.. 0 ..+I..+2

FIGURE 2.26

This is how the light meter looks when the camera thinks an image will be underexposed (too dark).

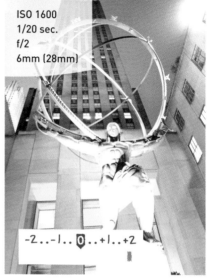

ISO 1600
1/20 sec.
f/2
6mm (28mm)

-2..-I.. 0 ..+I..+2

FIGURE 2.27

This is how the light meter looks when the camera thinks an image will be overexposed (too bright).

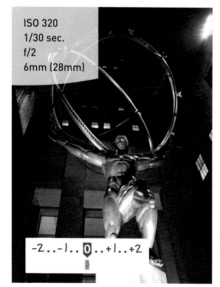

ISO 320
1/30 sec.
f/2
6mm (28mm)

-2..-I.. 0 ..+I..+2

FIGURE 2.28

When the camera thinks you've found a good combination of shutter speed, aperture, and ISO, the indicator will hover right in the center at 0 (zero).

TAKE YOUR METER FOR A TEST DRIVE

To see the meter in action for yourself, switch your camera to manual mode. With the lens cap still on, look at your light meter. (You can also cover the lens with your hand or stand in a dark closet.) It should be indicating under-exposure (–2).

Now, stick the front of your lens right up close to something really bright (like the bulb in the lamp on your nightstand). You should see a reading that indicates overexposure (+2). (Try not to blind yourself or start any fires while doing this, will ya?)

Try aiming the camera at other various scenes, and you'll see the light meter jumping all over the place.

THE METER IS NOT THE BOSS OF YOU!

While it's very helpful, the meter isn't perfect—so try not to get obsessed with the feeling that you can't take a photo unless the meter indicator is per-fectly centered (at zero), or the idea that a perfect meter reading will result in a perfect photo. The meter is merely a tool—definitely more of a guide than a commander in chief—so just think of it as an assistant to help you find a starting point for a decent exposure.

Remember that the camera doesn't know the scene you're facing, where the light is coming from, or the effect you're trying to achieve. The camera is lit-erally just measuring light and guessing whether or not it will be enough to record an image. Ultimately, the only thing that matters is what you think and feel about any test shots you take.

Would you be surprised to learn that your meter comes with its own set of options—called "metering modes"—that control the way it takes measure-ments? It's true! And the option you select can have a pretty huge impact on how helpful (or not helpful) the meter is to you. When you're shooting in one of the automated shooting modes, your metering mode can dramatically affect the exposure settings your camera chooses and the image that results. Curious? You'll learn more about it in Chapter 3.

For now, accept the fact that sometimes the meter will tell you that the photo you're about to take will be too bright or too dark, and occasionally you'll just have to smile and shoot it anyway because test shots (and ulti-mately, experience) will train you to know better.

GIVE MANUAL MODE A TRY

To put everything we've talked about up to this point into perspective, you really should roll up your sleeves and give manual mode a whirl for yourself. To get started, make sure your camera is set to manual (M) and find an interesting scene with a decent amount of light. Your living room, next to a large window (during the day), would be a great place to experiment.

If you're reading this at night while curled up on the sofa or in your bed, you can still switch your camera to manual and play with the settings to get a feel of how everything comes together. We will not be using flash for this exercise, so make sure it is turned off or otherwise put away.

Position yourself so that your back (or side) is to the window (just be sure you're not facing the window), and find something interesting on your coffee table to take a photo of. (Seriously, as **Figure 2.29** shows, this could be anything. A tray of buttons from the craft room, Valentine's Day cards from atop your desk, a spool of ribbon, a basket of odds and ends—heck, even your kid's action hero figurines would work!)

FIGURE 2.29
You don't need a fancy subject in front of your lens to try out manual mode—
just grab whatever is handy or easily within reach and get to it!

Get down at eye level, come in close, and move the objects around if need be to put together an interesting scene.

Now that our scene is set and we've got our subjects, we're ready to think about exposure. Since you're in manual (M) mode, the shutter speed, aperture, and ISO are all up to you. But where do you start?

SET THE ISO

It's probably easiest to start by setting a baseline ISO. In Chapter 1, you learned that ISO relates to how sensitive your camera is to light. The higher the number, the more sensitive your camera becomes.

Accessing your ISO might require pressing a button, turning a dial, or digging into your camera menu. If you've never done it before and aren't sure where to look, your camera's user guide will certainly be able to help.

I like to think of ISO 200 as home base and generally a good place to begin. If you're in a well-lit area (outside in broad daylight or inside with buckets of glorious light pouring through your windows), I recommend starting there.

If it's considerably cloudy out, or if there's just not much light coming through your window, try something more sensitive like 400 or 800. You can always return to this setting and make changes later, so remember that whatever you go with initially, it's just a place to start. For now, don't bother with the light meter—just pick an ISO as explained above, and move on.

One variable down, two more to go!

SELECT THE APERTURE

Let's lock down our aperture next. As you learned in Chapter 1, aperture is the opening inside the lens that controls the quantity of light that passes through.

If you've never done this before and aren't sure how to go about adjusting your aperture while in manual mode, pat yourself on the back—you're about to learn something new that will serve you well in the future. Look at you go!

Because all the manufacturers build their cameras so differently, and because no one wants to read (or write) a book that's 10,000 pages long, I'm afraid I'll have to refer you, once again, to your user guide. Just be forewarned— the way you adjusted the aperture earlier in this chapter (while shooting in aperture priority mode) might be different from the way you adjust your aperture setting while in manual shooting mode. So if you look it up in your user guide, be sure you're referencing the right section.

Still ignoring your light meter, set the aperture to something like f/5.6. Remember that this is just a starting point—literally a guess. It's not a rule or recommendation for any particular situation, but rather a loose suggestion based on what the lighting environment in your living room might be like and the capabilities of the lens you likely have attached (or built in) to your camera. Good guesses come with practice—and yours starts now. (Aren't you excited?)

DECIDE ON A SHUTTER SPEED

The final exposure variable to lock down is the shutter speed. If you don't already know how to change your camera's shutter speed while in manual mode, now is a good time to look it up. (I'll wait here.)

Since we already have the other two settings in place, we're ready to finish completing the last corner of the exposure triangle—with some help from the light meter. Take a look at your light meter (either through your viewfinder or on your camera's LCD screen) and adjust your shutter speed until the indicator arrives at or somewhere near the center of the meter—indicating what the camera believes to be a proper exposure.

What shutter speed is it that's making your meter happy? Keep in mind that some cameras display shutter speeds as whole numbers rather than the fractions they are; thus a shutter speed of 1/15th of a second may display as 15. Whole seconds are usually displayed with double quotation marks, so a shutter speed of 15 seconds would display as 15".

If the meter indicates that a shutter speed of 1/15 or slower is needed for a proper exposure, you may require a tripod. If that idea makes your nose wrinkle (who wants to mess with a tripod?), don't panic—you have options!

- Find something like a ledge, table, or countertop to steady your camera on and continue with the shutter speed the meter indicates.

- Switch back to your aperture setting and check if you can open it wider (by picking a *smaller* number) to let more light into your lens. Depending on your lens, you may be able to open the aperture even wider if you zoom your lens all the way out. This would then enable you to make the meter happy with a slightly faster shutter speed, thereby eliminating the need for a tripod.

- If your lens doesn't offer you a wider aperture (or if you don't want to change your current aperture setting), go back to your ISO setting and try raising it higher. Then, return to your shutter speed to compensate. With a more sensitive ISO, you should now be able to get away with a faster shutter speed.

If you've tried all of the above—and have set your ISO set as high as it can go—and the shutter speed required to make the meter happy is still really slow, see if you can turn on more lights. It must be pretty dark in there!

TESTING, TESTING—1, 2, 3!

Once you've got your settings selected and your meter looks happy, it's time to see how it all comes together—so fire away and click that shutter button!

How does it look? If it's too bright, you'll need to shield out more light by using any combination of the following:

- A faster shutter speed

- A smaller aperture (with a higher number)

- A less sensitive ISO

If your image is too dark, you can brighten it up by doing one of the following:

- Opening your aperture wider (how much wider will depend on your lens and possibly your current zoom setting—aka, focal length—as discussed in Chapter 4)

- Slowing down the shutter speed even more

- Making your ISO more sensitive by bumping it higher

If you didn't get the results you were hoping for on your first try, study the results, tweak your settings accordingly, and take another shot.

Rinse and repeat.

Manual mode is the real-life balancing (dare I say, juggling) act described in Chapter 1. Where your settings start and how far you're willing (or able) to push any part of the equation depends on what kind of photo you're trying to take and the lighting situation you're in.

YOU DID IT!

Though it feels clumsy and awkward (not to mention painfully slow) at first, believe it or not, with practice, manual mode can actually become faster and more reliable than any other shooting mode! Seriously. It's true. But even if manual mode doesn't become your No. 1 favorite, the important thing is that you were willing to give it a try. Bravo!

MANUAL MODE CHEAT SHEET

For those of you who are fans of step-by-step guides and charts, this one is for you!

1. Assess lighting conditions to establish a baseline ISO setting.

2. Decide what your priority is. A certain shutter speed? A particular aperture? Set the camera accordingly.

3. With the ISO set and either the shutter speed or aperture established, adjust the remaining variable until the light meter looks happy (with the indicator hovering around the center). Remember that the light meter is just a guide.

4. Take a test shot.

5. Assess the resulting photo.

6. If the shot is too dark, you could do the following:

 • Slow down the shutter speed to give the light more time to leave an impression (keep in mind that shutter speeds of around 1/30th, 1/15th, or slower may require stabilization to prevent camera shake)

 • Open up the aperture to let in more light

 • Increase the ISO to make the sensor more sensitive to existing light

 • Any combination of the above

7. If the shot is too bright, you could do the following:

 • Choose a faster shutter speed to reduce the amount of time the light is "burning" an image on the camera's sensor

 • Close down the aperture (make it smaller by choosing a bigger number) to reduce the amount of light coming in

 • Decrease the ISO to make the sensor less sensitive to the light

 • Any combination of the above

8. Make adjustments as needed based on the assessment in step 5.

9. Take additional test shots.

10. Repeat steps 5–7 until satisfied.

VISUAL FEEDBACK

As you are learning to notice the different effects that shutter speed, aperture, and ISO have on your images, it can be helpful to look back at photos you've taken to see what their settings were and how they impacted the resulting photo. On most cameras, it's as easy as playing back an image. If you don't see the exposure information, look for a button that says "Display" or "Info."

If you press this a few times while playing back an image, you should eventually see the exposure information displayed on the LCD screen alongside your image, as in **Figure 2.30**. You might even see the date/time and get a peek at the "histogram" (a bar graph representing the brightness values of the image).

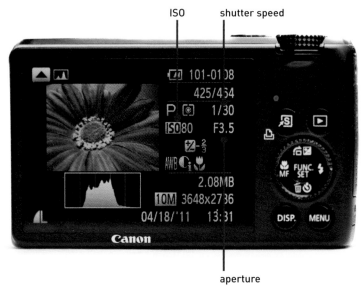

FIGURE 2.30

The info screen is helpful for reviewing your shots to see how different settings impact your images. In addition to the shutter speed, aperture, and ISO, what else does your info screen tell you about your photo? It might describe the shooting mode, image size, and resolution—among other things.

Another place you can examine the way your exposure settings affect your photos is on the computer. Once you've downloaded your photos, you should also be able to pull up this information in whatever software you use to manage and edit your images. The information you're looking for is called "metadata." If you can't easily locate it, check the software's help menu, where you can do a search for "metadata."

Familiarizing yourself with these settings and the impact they have on your images will help your photography skills grow by leaps and bounds. So instead of panicking the next time you bump into the info screen in Figure 2.30, take a second to explore it and make sense of the data it's sharing with you.

Chapter 2 Assignments

As you've seen, you have lots of options when it comes to shooting modes—from fully automatic to fully manual—and everything in between (not to mention scenes!). So resist the temptation to set your camera to a single mode and leave it there forever.

Learn Your Camera's Modes

Each camera is different—offering different options, placing them in different places, and even calling some of them by different names! Grab your camera and user guide, and spend some time digging around and exploring. What abbreviation does your camera use for shutter priority mode? Do you have a fully manual mode on your camera?

Be Shallow

Use your camera in either aperture priority or manual mode to create an image with a shallow depth of field, where only the main subject of your shot is in focus. From reading this chapter (as well as Chapter 1), you know that means you'll have to set your aperture to a small number/large opening. Starting from that setting, make adjustments as necessary to get a great shot with shallow depth of field.

Share your results with the book's Flickr group!

Join the group here: flickr.com/groups/gettingstartedfromsnapshotstogreatshots

3

ISO 125
1/125 sec.
f/4.5
14mm (64mm)

Function Junction

FLASH, WHITE BALANCE, EXPOSURE COMPENSATION, METERING, FOCUS, AND MORE!

Now that you've got a grip on the basics of photography and are familiar with the various shooting modes, learning to fine-tune your images is going to be a breeze!

Before we get started, it's important to remember that on most cameras, the functions available to you will vary *dramatically* depending on what shooting mode you're in.

My little nephew Haris loves to fish. I caught up with him on a dock one early evening where he was quick to show me his favorite part—the box of worms! This shot is one of my favorites from that session (even though we don't see his face) because I feel like it perfectly captures the small hands and tiny feet of his little three-year-old self.

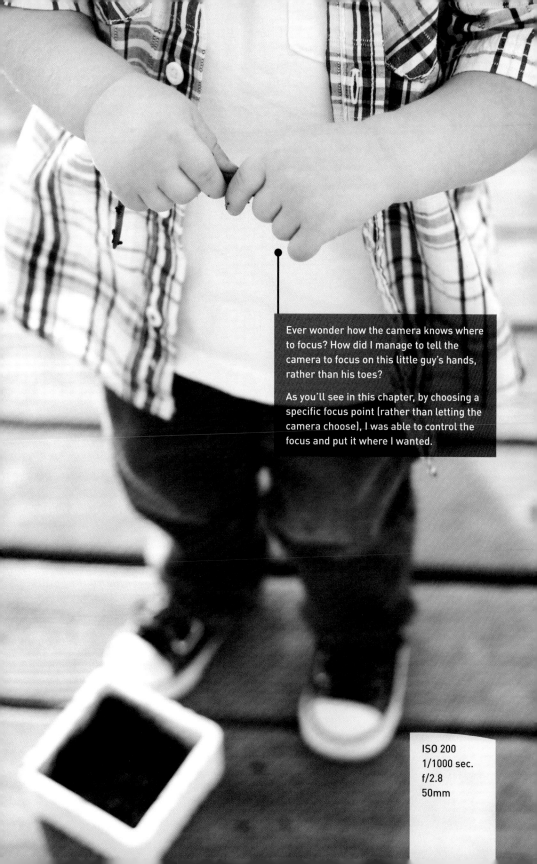

Ever wonder how the camera knows where to focus? How did I manage to tell the camera to focus on this little guy's hands, rather than his toes?

As you'll see in this chapter, by choosing a specific focus point (rather than letting the camera choose), I was able to control the focus and put it where I wanted.

ISO 200
1/1000 sec.
f/2.8
50mm

ACCESSING YOUR CAMERA'S FUNCTIONS

A lot of cameras won't let you play with the functions we're about to talk about if you're shooting in auto mode. So as you make your way through this chapter, if you're having a hard time finding or gaining access to a particular function, try switching from auto (A) to a less-restrictive shooting mode, such as program or any of the priority/manual modes. It's not that your camera is lacking, it's just that handcuffs and limitations are the bargain price for shooting in auto (A) mode. (Kinda makes you think twice, doesn't it?)

To make matters even more interesting, different manufacturers depict these functions in slightly different ways, often choosing to put them in different places from one camera to the next, but generally, they're pretty easy to find. The more you get comfortable looking around, the easier it gets.

FLASH

Even if you've never played with any of the other functions or modes on your camera, chances are you've at least bumped into your flash settings once or twice. So, as far as familiarity goes, it makes a great place to begin our functions tour.

Your garden-variety, on-camera flash comes in several flavors, including (but not limited to) auto flash, canceled flash, fill flash (I like to think of it as forced flash), red-eye reduction flash, and slow-sync (aka night portrait) flash.

Accessing these different flash modes is usually as simple as pressing a button. Depending on your camera, you may have to scroll a dial or turn a knob. It's usually an easy feature to get to, so if you've never bothered to find your flash options before, dig out your user guide and hop to it already!

AUTO FLASH

Auto flash means that the camera is in control and decides whether or not flash is needed in any given situation. Though the auto setting may be fine in some circumstances, to really take control of your photographs, you'll need to learn how to control the flash.

Auto flash mode isn't always everything it's cracked up to be. Sometimes it tells the camera to fire the flash when it's not really necessary, and other times it forgoes flash in a situation where you might really need it. Just as you have alternatives to auto shooting mode—thankfully—you also have alternatives to auto flash mode.

CANCELED FLASH

You may find that flash isn't as necessary as you think. In fact, you might discover that your photos can occasionally be greatly improved simply by turning the flash off. Doing so will force the camera to compensate for the reduced light in other ways (slower shutter speed, wider aperture, and/or a more sensitive ISO) and can result in much more natural-looking images.

Figure 3.1 was made with the camera set to auto flash, while **Figure 3.2** was captured on a camera that doesn't even have a flash. Amazing, isn't it? Even the baby is happier about the photo without the flash!

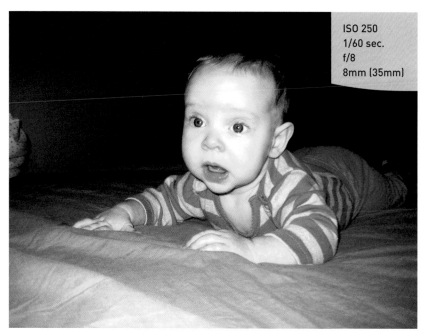

ISO 250
1/60 sec.
f/8
8mm (35mm)

FIGURE 3.1
Believe it or not, this image was captured in a well-lit room with a generously sized window behind the camera. But the camera's auto flash dramatically changed the look by brightly illuminating the subject and rendering the background a dark hole by comparison.

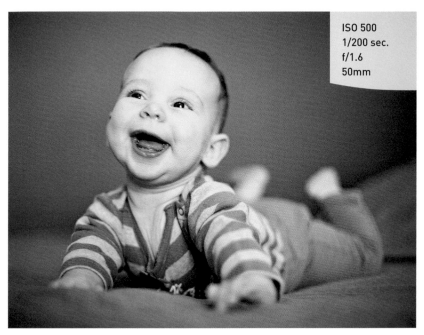

ISO 500
1/200 sec.
f/1.6
50mm

FIGURE 3.2
Captured only moments later, this image was recorded using only existing light with a camera that has no built-in flash.

Though there may not always be enough ambient (naturally existing) light to cancel the flash in every situation, you'd be surprised how often it works, and there are a few things you can do to help.

Shooting from a different direction that has more light, asking your subjects to turn around and face another way, and moving to a brighter part of the scene are all things you can do to take control of your situation and get better photos. See Chapter 7 for more about learning to see light and choosing your actions accordingly.

With a little bit of awareness and effort, you may be surprised how often you can get away without having to resort to flash. If you look around, there are all kinds of ways to get some great shots without flash, even at night! In our next example, Emir and I found ourselves in downtown Chicago with time to kill before catching a show. The daylight was gone, and much of the only illumination around us was coming from one of the plaza fountains. I decided it might be fun to shoot a silhouette portrait (where the light source is behind the subject). Armed with my older-model point-and-shoot camera, I asked Emir to stand in front of the fountain so I could position the camera on a nearby ledge (no tripod) and get a test shot.

Figure 3.3 is what we would've walked away with if I had been content to leave the flash set to auto mode. Because Emir was surrounded by so much dark background, the camera felt compelled to fire the flash, even though I didn't need (or want) it for the shot I had in mind.

ISO 200
1/60 sec.
f/2.8
6mm (28mm)

FIGURE 3.3
With the flash set to auto, the camera attempted to compensate for the dark surround-
ings by firing the flash, thereby ruining any hopes for a silhouette portrait.

The difference between the disappointing image in Figure 3.3 and the shot we had in mind (**Figure 3.4**) was as simple as canceling the flash.

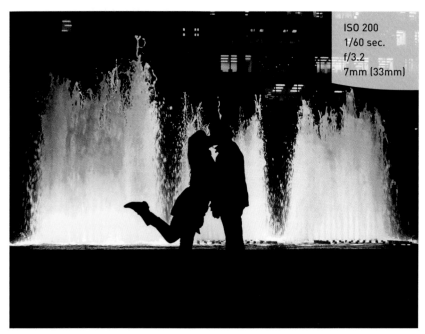

ISO 200
1/60 sec.
f/3.2
7mm (33mm)

FIGURE 3.4
By canceling the flash (and using the camera's built-in self-timer), I was able to get the silhouette portrait I originally had in mind.

After framing the shot the way I wanted (read about "composition" in Chapter 7), I canceled the flash, turned on the self-timer (more on this later in this chapter), and ran to get into the shot next to Emir before the shutter clicked. Violà!

Canceled flash is also great in those situations where the use of flash is not allowed (museums, tour buses, etc.). In short, turning off your flash is worth exploring and getting very comfortable with. In fact, it may even become your preferred modus operandi! I generally operate with my flash set to the canceled mode unless I have a compelling reason to turn it back on.

FILL FLASH (AKA FORCED FLASH)

This option is the perfect solution for times when the camera doesn't think flash is necessary, but you disagree. You can override the camera by choosing the fill flash setting, thus forcing the flash to fire—whether the camera thinks it should or not.

Fill flash is especially useful when the background behind your subject is brighter than the subject is. Depending on your metering mode (read about this later in the chapter), a background that's brighter than your subject can

sometimes trick your camera, resulting in a great photo of the background—and a subject that's too dark, as in **Figure 3.5**.

By simply enabling fill flash, I was able to get the image I wanted in **Figure 3.6**.

ISO 160
1/800 sec.
f/4
9mm (42mm)

FIGURE 3.5
The brightly lit background factors too heavily into the camera's exposure calculation, causing the camera to forego the flash, resulting in a properly exposed mountain scene while poor Emir is left in the dark.

ISO 500
1/1600 sec.
f/4
9mm (42mm)

FIGURE 3.6
Fill flash saves the day by bringing up the exposure on Emir to match the brightness of the surrounding mountains.

Bottom line? Anytime you need to be sure the camera's flash will fire (regardless of whether the camera thinks it should), this is the option to reach for.

RED-EYE REDUCTION FLASH

The scary-looking red eyes occasionally seen in flash photos (**Figure 3.7**) are caused by the flash reflecting off the blood supply in the back of your subject's eyes. The red-eye reduction flash option attempts to make everyone look less frightening by emitting a series of flash bursts before taking the actual photo. The first few bursts constrict the pupils, so by the time the real flash fires, there is less opportunity for the light to be reflected back from behind the retinas (**Figure 3.8**). Pretty sweet, huh?

The only bummer about red-eye reduction flash mode is that because the camera fires a series of flash bursts (instead of a single burst), subjects (especially young children) often assume the photo is finished after the initial burst and tend to take off too soon. Thus, it can be helpful to let your subjects know to expect a series of flashes so they don't split after the first one!

ISO 200
1/60 sec.
f/4.5
18mm (82mm)

FIGURE 3.7
My nephew Cole demonstrates what can happen without red-eye reduction flash.

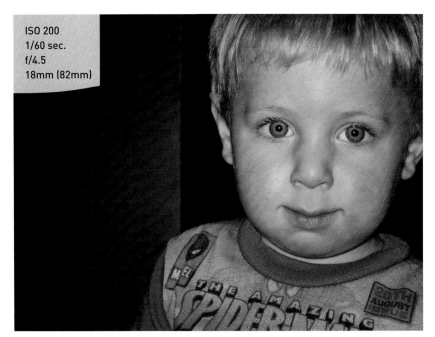

ISO 200
1/60 sec.
f/4.5
18mm (82mm)

FIGURE 3.8
Red-eye reduction flash to the rescue!

PETS AND "SHINE-EYE"

The "shine-eye" effect often seen in pets is caused by light reflecting off a mirror-like layer in their eyes. Unfortunately, the red-eye flash reduction function doesn't have the same effect on pets as it does on people.

SLOW-SYNC (AKA NIGHT) FLASH

This is that wild card again! If this function is hiding from your flash functions, chances are you'll find it within your camera's shooting modes or as part of your scene collection, where it might also be known as "night portrait" mode. As usual, check your user guide to be sure.

If you've ever tried taking a portrait at night (or someplace dark, like at a wedding reception), you may have noticed that while your subject is plenty bright, the background tends to turn into a big dark hole as seen in **Figure 3.9**. Not good!

ISO 640
1/60 sec.
f/4
23mm

FIGURE 3.9
With the flash (and the camera) set to auto, Emir is brightly illuminated, but the dark background surrounding him is out of the flash's effective range and doesn't stand a chance.

The slow-sync flash setting attempts to reconcile the difference between your flash-lit subject and the dark background extending beyond the reach of the flash by using a slower shutter speed, as in **Figure 3.10**.

If you remember back to Chapter 1, you know that shutter speed controls time. By slowing down the shutter speed, the camera gives the background some additional time to "burn in" and leave an impression on the camera sensor.

Pretty slick, eh? The flash is there to light your subject, and the slower shutter speed gives the surrounding background a fighting chance. Don't you feel fancy now? Give your camera (and yourself!) some props; it's loaded with all kinds of goodness like this, but it only works if you put it to use.

ISO 640
1/6 sec.
f/4
23mm

FIGURE 3.10
The slow-sync flash setting tells the camera to slow down the shutter and give the background (not lit by the flash) the opportunity to be seen.

WHITE BALANCE

Did you know that different light sources emit light of different colors? It's true! For example, you've probably noticed that candlelight produces an orange-ish glow that is quite different from the color of light coming from the fluorescent bulbs usually found above a corporate cubicle. You've also spent a lifetime witnessing the changing color of sunlight as the day progresses from morning to night, becoming a warmer shade of yellow shortly before the sun sets (often referred to as the golden hour).

COLOR TEMPERATURE

The difference in color from various light sources is referred to as "color temperature." Though measured in degrees similar to the way we measure physical temperature, color temperature is not calculated as part of the Fahrenheit or Celsius scales, but rather a scale all its own called "Kelvin."

White balance has to do with the way your camera deals with all the different colors of light, continually attempting to correct or balance the color to produce an accurate image.

Color balance problems are responsible for all kinds of photographic disharmony and are especially common in places like high school gymnasiums, your office, and even under the shade of your favorite tree. These problems arise when the camera misinterprets the color temperature of the scene. While our brain can adjust for these discrepancies, the camera needs a little help and relies on the built-in white balance settings to help it neutralize the color.

You may not have realized it before, but your camera lovingly serves up a variety of white balance presets that may include Auto, Sunny, Cloudy, Shade, Tungsten, Fluorescent (your camera may even offer several varieties of fluorescent), and Flash.

Some camera models might have additional presets such as Kelvin, which allows you to dial in a specific color temperature from the Kelvin scale, and Custom, where you can create your own preset based on your current shooting environment. Consult your user guide for specifics.

TUNGSTEN/INCANDESCENT

Tungsten bulbs are also referred to as "incandescent" and are the type of bulb we depict floating above someone's head when they've had a brilliant idea. They're also the same ones you'd likely find in your own home (unless you've switched to compact fluorescent).

When you take a photo, the camera analyzes the image data and compensates for color temperature using whichever white balance you've selected. There's no shame in defaulting to auto white balance for most situations; just be ready and willing to change it when the color starts to look wacky.

On most cameras, white balance settings are found within the menu system, but some models have a button dedicated specifically to white balance settings. Dig around and check your user guide to make sure you know how to access and adjust yours. In **Figures 3.11–3.16**, the same scene was photographed using a variety of white balance settings. Notice how the colors vary. In some cases (not necessarily in this example), the differences can be quite dramatic.

ISO 640
1/160 sec.
f/5
100mm

FIGURE 3.11
Auto

FIGURE 3.12
Sunny

FIGURE 3.13
Shade

FIGURE 3.14
Cloudy

FIGURE 3.15
Tungsten

FIGURE 3.16
Fluorescent

Changing your camera's white balance settings only changes how future photos will look—it doesn't affect photos you've already taken. Knowing this helps you be more proactive in your shooting. When moving from one shooting environment to another, check your camera settings and fire off a few test shots before getting serious. Then, adjust your white balance as necessary, and you'll be ready to go without missing any of the action! Like so many other things, there is no right answer when it comes to white balance. (Don't you love that?) Keep in mind that while it often works well to choose the white balance setting that most closely matches your shooting environment, you certainly don't have to. Intentionally mismatching your white balance can be a fun creative tool, so don't be afraid to experiment!

EXPOSURE COMPENSATION

Have you ever shot a photo that was almost perfect except that it was a bit too dark (underexposed) or a bit too bright (overexposed)? What did you do?

As amazing as your camera is, it's still at the mercy of its light meter and sometimes needs a little help to get the exposure you want. That's where exposure compensation comes in. You've likely had the power of exposure

compensation all along and just never knew it! Instead of having to accept photos that aren't quite what you hoped for, you can force the camera to try again with different exposure settings to either darken or brighten the image.

FIXING IT IN PHOTOSHOP

If your answer to dealing with exposure problems has been to "fix it later in Adobe Photoshop," consider this your intervention! While Photoshop is an amazing tool, it is not a crutch. Your goal should be to get it right in the camera, not to fix it later in Photoshop.

To get started, check your camera for a symbol that looks like a box with a +/- symbol inside it. If you can't find it, cozy up with your user guide—it's in there somewhere! Some camera models display exposure compensation as a linear graph similar to **Figure 3.17**. It may look quite a bit like the light meter we talked about in Chapter 2.

The zero in the middle represents what the camera believes to be the correct exposure. You can push the exposure to better suit your fancy anywhere from a maximum of two stops darker (–2) to two stops brighter (+2), typically in 1/3-stop increments.

To change your camera's exposure settings, just move the indicator in either direction, depending on whether your goal is to darken (–) or brighten (+) the image. The further you move the indicator away from the center, the more significant exposure difference you will make. (Consult your user guide if you're not sure how to adjust the exposure compensation settings on your particular camera.)

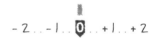

FIGURE 3.17
Some cameras display exposure compensation in a way that's very similar to the light meter itself.

Depending on your camera, exposure compensation might be depicted numerically as in **Figure 3.18** instead. A display of ± 0 means exposure compensation is set to zero (neutral) and the camera will expose as it sees fit. If you want to push the exposure darker or brighter, you simply adjust the numbers accordingly. Negative numbers (–2, –1) will make exposure darker, and positive numbers (+1, +2) will make the exposure brighter.

FIGURE 3.18
Some cameras represent exposure compensation numerically.

EXPOSURE COMPENSATION AND MANUAL MODE

Exposure compensation is irrelevant if you're shooting in manual mode. Why? Because you have full control in this mode, and you're free to shoot with whatever exposure you want. So if you need to push the exposure one way or another, just change the settings accordingly. In this sense, you are your own form of exposure compensation.

Once you've adjusted the exposure compensation, you'll need to take another photo for the new settings to be used. Just like white balance, changes you make do not affect images you've already taken—only new ones you're about to take. **Figures 3.19–3.23** show the Brooklyn Bridge shot with varying exposure compensation settings ranging from –2 to +2. Which one do you like best?

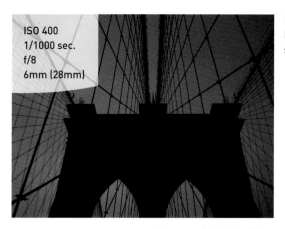

ISO 400
1/1000 sec.
f/8
6mm (28mm)

FIGURE 3.19
Exposure compensation
set to –2.

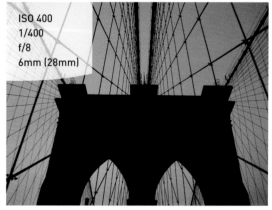

ISO 400
1/400
f/8
6mm (28mm)

FIGURE 3.20
Exposure compensation
set to –1.

ISO 80
1/320 sec.
f/2.8
6mm (28mm)

FIGURE 3.21
Exposure compensation set to 0.

ISO 400
1/100 sec.
f/8
6mm (28mm)

FIGURE 3.22
Exposure compensation set to +1. Out of this whole series, I like this frame the best. Remember there's no right or wrong—it really comes down to personal preference.

ISO 400
1/250 sec.
f/2.8
6mm (28mm)

FIGURE 3.23
Exposure compensation set to +2.

To shoot your own series of images like Figures 3.19–3.23, follow these steps:

1. Find a scene you like.

2. Set your exposure compensation to –2, and take a photo.

3. Adjust the compensation to –1 and take another photo.

4. Take a third photo with the exposure compensation set to 0, another one set to +1, and a final image set to +2. (If you want to be very detailed, you could take a photo in 1/3-stop increments instead of full-stop increments, so after –2, your next photo would be set to –1-2/3, and so on. But that would leave you with a lot of images!)

The more you play with the power of exposure compensation, the more intuitive the process will become. Before you know it, you'll be able to actually guess the settings that will best suit your tastes.

Can you believe you've had this power all along and just never knew it?

TAKING TEST SHOTS

Just like white balance, changing your exposure compensation doesn't change the photos you've already taken; it just prepares the camera to take a better photo next time. So it's best to take some test shots before any important moments to make sure you're set up to capture the good stuff the way you were hoping to.

FLASH COMPENSATION

In addition to being able to nudge the overall brightness or darkness of your image with exposure compensation, some cameras also give you the ability to nudge your flash power with something called "flash compensation."

If your camera supports this feature, you'll likely find it represented with an icon that looks a lot like the exposure compensation icon, but with a lightning bolt added. Check your user guide for its specific whereabouts on your particular camera.

It works just like exposure compensation, except the only thing being adjusted is the flash output. While adjusting it won't necessarily give you the power to

light up the whole room, it can definitely have an impact on the brightness level of the subjects directly in front of you.

Need a more powerful flash? Crank it up toward +2 or so; then, take another shot. If your flash is blasting everyone overboard, dial it down toward –2, try again, and see what you think.

SELF-TIMER

You probably already know that your camera has a built-in self-timer that allows you to press the shutter button, and after a set amount of time, the camera takes the picture. The settings are typically preset for varying durations, usually including 10 or 2 seconds. You might also have a custom feature where you can set the timer for different lengths of time better suited to your purpose.

The 10-second setting is great when you want to put the camera down and join the rest of the group by actually being in the photo for once! With a tripod, a countertop, or anything to steady the camera, you can make sure you don't miss out on all the fun (**Figure 3.24**)!

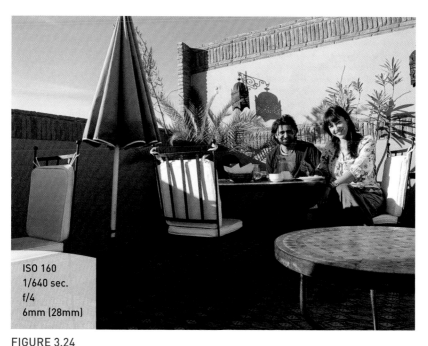

ISO 160
1/640 sec.
f/4
6mm (28mm)

FIGURE 3.24
I set my camera on a nearby tabletop and used the self-timer feature to join Emir for this portrait.

What about the 2-second setting? You'd have to be pretty fast to press the shutter button on the camera and find your place on the other side of the lens before the shutter fires in only two short seconds! Instead, this shorter timer setting is great for low-light situations or any other time you might be using a slower shutter speed when—even with a tripod—the very act of pressing the shutter button could be enough to cause the camera to shake and blur your image.

The 2-second setting gives the camera enough time to stop wiggling between when you press the button and when the shutter finally clicks. Surprisingly simple, right?

MULTIPLE SHOTS WITH THE SELF-TIMER

Some cameras make it possible to use the timer to capture not only a single photo, but a few in a row, saving you from having to run back and forth for retakes when you've joined the other subjects in front of your own lens. Cool!

METERING MODES

You may not change your metering mode or focus drive (which we'll discuss later in the chapter) the way you change your socks—or the features we've mentioned in this chapter so far—but if you run into a jam (or your three-year-old gets ahold of your camera and manages to change all the settings), it's infinitely helpful to at least know what you're dealing with, let alone how to fix it. So hang in there; you're making progress!

As you learned in Chapter 2, metering is what your camera does to deter-mine proper exposure. It's the process of measuring the light in a given scene and calculating an exposure based on those measurements, and—as luck would have it—there are several different ways to do it.

You may be wondering, "Why would anyone want or need more than one way to meter the light in a scene?" What a great question! To understand the answer, it helps to understand how the meter works.

Your camera's built-in light meter works by measuring the light reflecting back from whatever is in front of your lens. In any given scene, you may have some objects that reflect a lot of light and others that reflect substantially less. This presents a challenge when it comes to metering, because it's entirely possible to have areas of extreme brightness next to areas of considerable darkness, which will need to be reconciled in one form or another.

It's also not uncommon to find yourself in a situation where a large light source is actually behind your subject rather than in front of it, as when you are photographing people standing in front of a bright window.

This can make it tricky to get the exposure right, resulting in photos you may not be so fond of. Therefore, it's helpful to have a way to tell your camera which part of the scene you care about the most (which part you want to be sure is properly exposed). When combined with "auto exposure lock" (explained later in this chapter) you will be a force to be reckoned with!

As always, there's a chance your specific camera manufacturer may refer to these modes by different names or with slightly different icons, but the way they operate is pretty standardized. If you come across anything confusing, check your user guide for answers.

Before we get into how each mode works, grab your camera and take a moment to figure out how to access the metering modes of your particular model. The options available will vary from model to model, and finding them may be a bit trickier than finding your flash or white balance options that we discussed earlier in this chapter.

A few camera models have a dedicated button for metering modes, but on most others, you'll find them tucked into a menu option somewhere. You'll know you've found them when you either bump into a menu item conveniently called "metering modes," or you come across an icon that looks something like a square with a circle in the middle of it. (When in doubt, look it up!)

In the following sections, we will take a look at these modes:

- Evaluative or matrix metering
- Center-weighted
- Partial
- Spot

EVALUATIVE (AKA MATRIX)

Evaluative (matrix) metering mode is the PB&J of metering—and who doesn't like PB&J? The go-to metering mode for most situations, it works by meter-ing the light across the entire scene, then averaging the whole thing together to create an exposure (**Figure 3.25**).

FIGURE 3.25

The shaded area represents the way evaluative (matrix) metering mode calculates exposure by averaging together light in the entire scene.

CENTER-WEIGHTED

Although center-weighted metering mode still collects and averages expo-sure data from across the entire scene, the information gathered from the center area is given special consideration when it's figured into the final exposure calculation. In other words, the camera measures light across the whole scene, but it plays favorites with information gathered from the center, as depicted in **Figure 3.26**.

FIGURE 3.26

Even though center-weighted metering mode still calculates exposure by averaging the entire scene, it gives special consideration to the area in the center of the scene, as indicated by the overall shading with the darker shading in the center.

Because evaluative (matrix) mode is often considered to be general purpose, your camera is probably set here by default, which isn't necessarily a bad thing. It's a fine place to be—until you have problems, at which point you'll be glad there are other options.

PARTIAL

Unlike evaluative (matrix) and center-weighted modes, partial metering mode does not consider the entire scene when calculating exposure. Instead, it bases the exposure calculation on the area in the center of the viewable scene, as represented in **Figure 3.27**.

FIGURE 3.27
Unlike some of the other modes, partial metering mode does not consider the scene as a whole when determining exposure. Instead, it bases the entire calculation on a small area around the center of the frame, represented here with the shaded circle.

Because the meter is taking a targeted reading of a very specific part of the scene (rather than averaging the whole frame), you're able to tell the camera which part of the scene you want to base the exposure on by positioning it in the center of the frame, locking the exposure (with auto exposure lock, explained later in this chapter), then recomposing the scene as desired.

This is helpful in backlit situations where there is a lot of light coming from behind the subject (like when they're in front of a window or are being photographed outdoors on a ski slope where the surrounding snow could otherwise throw the exposure meter off balance). If you were to use a different mode, like evaluative, in such a situation, the camera would average the difference between the bright snow and the dark subject, resulting in an exposure that's not a good match for either.

SPOT

Similar to partial metering, spot metering mode calculates exposure based only on a very specific point within the frame, rather than the scene as a whole. Compared to partial metering, spot metering targets an even smaller area within the center of the total frame, as shown in **Figure 3.28**.

FIGURE 3.28

The small shaded circle in the center of the frame represents the small and targeted area that area spot metering mode uses to calculate exposure. Similar to partial mode, spot metering mode does not consider the scene as a whole—only the very limited area in the center of the frame.

As with partial metering mode, this is useful if you're photographing a scene with backlighting or one where your subject occupies a small portion of the frame and the exposure varies dramatically from the rest of the scene, such as a person lit by a spotlight on an otherwise dark stage. When you use it with auto exposure lock (explained below), you can achieve especially pleasing results.

AUTO EXPOSURE LOCK (AEL)

Once you decide on a metering mode, you can use auto exposure lock (AEL) to tell the camera which part of the scene you want to base the exposure on. The settings will then be locked, so nothing changes while you recompose (move your subject somewhere besides the center of the frame) and take the picture. (See Chapter 7 for details on photographic composition.)

To give you an idea of how powerful AEL can be, take a look at **Figures 3.29** and **3.30**. Believe it or not, they were captured in the same scene, with the same lighting conditions, just moments apart. The only difference is that Figure 3.29 was captured with the exposure locked on the bright sunny scene outside the window, and the exposure in Figure 3.30 was locked on my friend Paul (inside).

ISO 160
1/640 sec.
f/4
6mm (28mm)

FIGURE 3.29
Exposure is locked on the bright, sunny scene outside the window.

ISO 200
1/30 sec.
f/2.2
7mm (33mm)

FIGURE 3.30
Exposure is locked on my friend Paul (inside).

AUTO EXPOSURE LOCK

On most cameras, auto exposure lock is already programmed into the shutter button. (Check your user guide to know for sure; some cameras have a dedicated AEL button.)

Using auto exposure lock is simple. Just follow these steps:

1. Position your subject in the center of your frame (**Figure 3.31**).

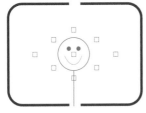

FIGURE 3.31
Positioning your subject in the center of the frame is the first step when using auto exposure lock.

2. Press the shutter button halfway down to lock in the exposure.

3. Continue to hold the button halfway down while you reposition the subject where you want it to be within the frame (**Figure 3.32**). You'll notice that as you move the camera around, pointing it at different objects, the exposure is locked and does not change.

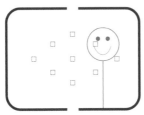

FIGURE 3.32
After locking the exposure, recompose the scene to position the subject where you want it before taking the picture.

4. Press the shutter button the rest of the way when you're ready to take the picture.

That's it. Simple, right?

Remember, just because you have to put your subject in the center of the frame to help the meter get the exposure right doesn't mean you have to leave it there while you take the picture! See Chapter 7 for more about composition.

HOW WOULD YOU USE THIS IN REAL LIFE?

Take a look at **Figure 3.33**, captured without AEL, using evaluative (matrix) metering mode. Because this mode averages exposure data from across the whole scene, it got tripped up by the brighter background outside the window (behind the subject) and overcompensated with an exposure that's too dark.

ISO 200
1/320 sec.
f/4
7mm (33mm)

FIGURE 3.33
Using the default setting of evaluative metering mode, the camera averaged the whole scene together. Because the large, bright background was factored into the equation, the resulting image was underexposed.

With quite a bit of difference in brightness levels between where we sat (inside) and the outdoor patio behind Emir (outside), I switched the camera to spot metering mode to avoid averaging the two areas together. Then, I used AEL to let the camera know I wanted the exposure based on Emir's face. The result can be seen in **Figure 3.34**.

ISO 200
1/80 sec.
f/4
7mm (33mm)

FIGURE 3.34
After switching to spot metering mode, I positioned Emir's face in the center of the frame to get the proper exposure, then used AEL to prevent the settings from changing while I repositioned him slightly off center and took the picture.

WHY NOT JUST USE FILL FLASH?

Whenever you're faced with extreme exposure differences within the same scene, you have choices about how you handle it. In the previous example, I chose to avoid flash for three reasons:

1. I prefer the look of natural light to that of direct flash.

2. Because Emir is sitting in front of a window, the flash would have created a glare behind him, which I definitely wanted to avoid.

3. If I had used fill flash, I wouldn't have this great example of AEL and spot metering mode to share with you!

Of course, there are advantages and disadvantages to either choice you make. In this case, I was able to avoid glare on the window behind Emir, but at a cost. In order to expose him correctly (without flash), the brighter area behind him ended up overexposed.

Photography is all about making choices. The trick is to know what your options are—and then choose accordingly. C'est la vie.

FOCUS

How many times have you felt like you would've had the perfect photo—if only it had actually been in focus? If you're like most people, you've probably experienced this more times than you care to remember, right?

While there isn't a way to guarantee that every photo you ever take will be in perfect focus, there are things you can do to increase your chances of getting sharper images.

Exploring your camera's auto focus modes and various focus point options can have a profound impact on your ability to successfully capture the photo you're looking for. While these settings may not be as glamorous or imme-diately gratifying as some of the other settings we've covered thus far, don't let that stop you. Roll up your sleeves, grab your user guide, and read on!

AUTO FOCUS MODES

Can you believe your camera has more than one way to approach something as seemingly simple as focusing? The options may actually surprise you!

Some of these settings change automatically when you select certain shoot-ing modes or scenes (see Chapter 2). But in the event that they don't—or you

prefer to take charge and change them for yourself—it's advantageous to know what your choices are.

If your camera is one that gives you access to these settings, either it will have a dedicated button for this purpose, or you'll find it listed within your menu settings. If you don't already know where your auto focus modes are, take a moment to refer to your user guide and find them before reading on.

ONE SHOT OR SINGLE

If you've never changed your settings from factory default (or have never taken advantage of the sports shooting mode we discussed in Chapter 2), then your shooting experience thus far has likely been confined to what's typically referred to as one shot (or single) auto focus mode.

In this mode, when you press the shutter button, the camera pulls focus once, then holds tight until the image capture is complete. This is great for most shooting circumstances where your subject isn't moving around much (**Figure 3.35**), but it can be a challenge when you're trying to shoot a moving target whose focal distance is continually changing (for example, moving toward or away from the camera).

ISO 200
1/1000 sec.
f/6.3
6mm (28mm)

FIGURE 3.35
One shot (single) auto focus mode is the default for everyday shooting and is capable of great results, even in scenes like this. Although the subject is moving, the distance between him and the camera is steady, as he's not moving toward or away from the lens.

CONTINUOUS OR SERVO

As the name suggests, continuous auto focus mode enables your camera to track a moving object. Yep. You read that right. It can actually track your subject as it moves within the frame! Isn't that amazing?

It works by continually focusing (rather than pulling focus just once) for as long as you're pressing the shutter button halfway.

That's the catch. You're required to hold the button down halfway, allow the camera to focus, and then keep holding the button down, following your subject with the camera and keeping them in the frame. The camera will continually focus, so when you finally take the photo, all will be well. You can see the results of continuous auto focus mode in **Figure 3.36**.

ISO 320
1/400 sec.
f/2.8
16mm

FIGURE 3.36
Continuous (or servo) auto focus made it possible for me to maintain focus on Rachel and Jeff as they raced past the camera.

CONTINUOUS FOCUS AND AUTO EXPOSURE LOCK

Shooting in servo focus mode may—depending on your camera model— override your option to use auto exposure lock (or may lock exposure while tracking focus at the same time). When in doubt, check your user guide.

CONTINUOUS FOCUS: TOO GOOD TO BE TRUE?

Continuous focusing may sound like a dream come true, leaving you wondering why you wouldn't just use it all the time—right? Like all the modes and functions built into your camera, there are advantages and disadvantages. Depending on the scene (and your shooting style), there are times when having the camera continually focus on whatever is grabbing its attention can actually cause you to end up with more shots out of focus than if you had used a different auto focus mode.

For best results, practice and get comfortable with your camera's menu system so you can change settings quickly in response to any situation.

ADDITIONAL FOCUS OPTIONS

Some camera models have an additional focus mode that automatically switches between one shot (single) and servo (continuous) modes as needed. If your subject starts out in one spot, then suddenly takes off on a dead sprint toward your lens, this mode will keep up! Check your user guide for details.

FOCUS POINTS

Have you ever wondered how your camera knows what part of the scene to focus on? How does it know whether you want little Bobby—or the puppy running around in the yard behind him—to be in focus?

Most cameras leave the factory with a default setting where the camera basically guesses. You may have witnessed this if you've ever been shooting, and various boxes or squares appeared on different parts of your screen in response to whatever is in front of your lens, similar to what you see in **Figure 3.37**.

Some cameras take this a step further with what is called "face detection" (which might hijack your white balance and exposure settings—check your user guide for the specifics).

As an alternative, some cameras will let you select one of several specific focus points (**Figure 3.38**). This makes it easy to choose a point of focus, compose the shot, and capture the image. (Though it takes practice to get used to regularly changing your focus points, it can be done!)

FIGURE 3.37
By default, most cameras automatically select focusing points for you, shown here as orange boxes.

FIGURE 3.38
Some camera models will let you select one of several focus points with the ability to change them from shot to shot to suit your subject and composition. (The pattern and availability of the points on your camera may vary.)

Even if your camera doesn't give you the option to choose from several focus points, chances are it will, at least, let you set a single focus point at the center of the frame, as seen in **Figure 3.39**. Rather than having the focus point jump around while the camera plays guessing games, you can breathe easy and count on the focus area to stay put in the center of the frame.

FIGURE 3.39
Almost all cameras will let you cancel the default auto point selection feature and opt for a fixed center focus point instead.

Because most cameras combine auto focus lock with auto exposure lock, you should be able to use the same technique you just learned of positioning your subject in the center of your frame, then pressing and holding the shutter halfway down while you recompose before taking the photo.

If you've ever felt as if the auto focus point selection option was a toss-up, making it tricky to predict what the camera will decide to focus on, you may become a big fan of fixed center point focus. It leaves one less variable to guess at or leave to chance.

DRIVE MODES

Somewhat similar to the way cars are capable of operating in different gears, you have a couple of different options for drive modes when it comes to your camera, and as you're about to see, they're pretty self-explanatory.

SINGLE (ONE) SHOT

In single shooting drive mode, the camera takes one photo each time you press the shutter button. Plain and simple. This is where the camera is set to as a default, and it is where it will likely spend most of its time.

CONTINUOUS SHOOTING

If you're shooting a wildly moving subject or trying to catch a specific moment in action—the very moment your kid scores the winning soccer goal, for example—you can up your chances of success by using continuous shooting mode to essentially turn your camera into a rapid-fire machine gun. As long as you continue to hold the shutter button down, your camera will happily fire away.

The number of frames per second that your camera is capable of capturing will vary from model to model, but either way, it's pretty impressive. With the camera's drive mode set to continuous (and the focus mode also set to continuous, thereby tracking moving subjects), I was able to capture a series of frames as my subjects blew past my lens, seen in **Figures 3.40–3.42**.

ISO 320
1/400 sec.
f/2.8
19mm

FIGURE 3.40

The first of three images in a series, captured using continuous drive mode.

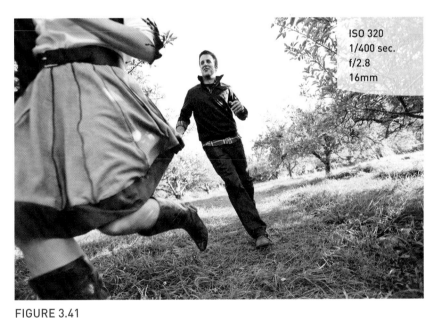

ISO 320
1/400 sec.
f/2.8
16mm

FIGURE 3.41

The second of three images in a series, captured using continuous drive mode. Of all three frames, this one is my favorite. If I had shot in single shot drive mode, I would've had to rely on perfect timing to score this. Continuous drive mode is much, much easier!

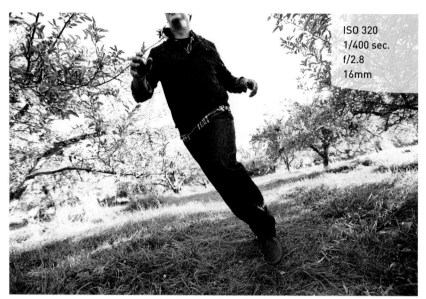

ISO 320
1/400 sec.
f/2.8
16mm

FIGURE 3.42

The third of three images in a series, captured using continuous drive mode.

You may be wondering why you wouldn't just leave your camera set to con-tinuous mode all the time. While you could, you'd quickly find yourself firing off five or more frames when you mean to shoot only one, rapidly piling up on your memory card and wasting space on your hard drive later.

So, while continuous shooting is great for catching key moments in sports or other action shots, having your camera operate like a machine gun is overkill for most situations and tends to get old quickly. And—even if you wanted to—continuous drive mode doesn't mean you can hold the button down for hours on end and take 10 bazillion shots in a row without interruption. Your camera can only fire off a certain number of photos in a single round (called a "burst") without having to pause to catch its breath, as each photo must be stored in active memory until it can be written to the memory card. The memory buffer is only so big and can only handle so many photos at a time—regardless of the camera's frames-per-second rate. If you attempt to hold the shutter button down for extended periods of time, the camera will eventually be forced to suspend shooting to clear the buffer memory before it can continue.

The bottom line? Stick to single shot drive mode for most things, and make use of continuous when you really need it.

THAT'S NOT ALL, FOLKS!

This is all just the beginning! There's an endless list of other functions and features your camera may offer. Things like smile recognition, panorama assisting, and color effects like sepia or black and white are just a few. These features tend to vary so dramatically from camera to camera that it doesn't make sense to try and include them all here.

Experience has taught me that if you've made it this far into the book and have taken the time not only to locate everything we've talked about on your camera but also to really play with and get a feel for how things work, you'll have no problem discovering and making use of these other features. Have a little faith in yourself, and don't be afraid to explore!

Chapter 3 Assignments

This concludes our camera function tour, and I'm glad to see you've hung on for the ride! Your camera thanks you and looks forward to stretching its legs next time you take it out for a spin.

Find Balance in Your Life

Find one subject in any particular light, and test out your white balance settings. You will be amazed at how the resulting picture looks "right" or "wrong" to you—or just plain interesting—based on your white balance setting.

Controlling Exposure

Place a friend in front of an especially bright or dark background, and test out your ability with various metering modes and your camera's ability to lock the exposure. Also work with your exposure compensation feature, and see how they all work together or separately to help you get the shot. This will take some practice, but learning how to work these two functions is key to great shots in the future!

On the Move

Find a moving target—whether that's a friend jogging or some cars whizzing by— and try out the different focus and drive modes to get a handle on what works best for you when shooting motion.

Share your results with the book's Flickr group!

Join the group here: flickr.com/groups/gettingstartedfromsnapshotstogreatshots

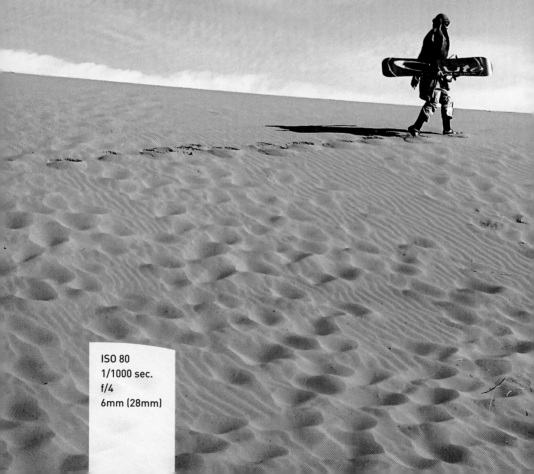

4

ISO 80
1/1000 sec.
f/4
6mm (28mm)

Gettin' Your Glass On

THE LOWDOWN ON LENSES

Telephoto or wide? Zoom or prime? What about macro? What does it all mean, and who really cares?

For a lot of people, making the decision about what camera to buy is tough enough, but choosing a lens to go with it? Sheesh. Because they're treading in unfamiliar territory, people often find themselves at the mercy of whichever salesperson is around, possibly leaving the store with little to no understanding of what they just bought, how to use it, or if it's really what they were looking for. As it turns out, the lens you choose (or that comes built into the camera you buy) plays a more integral role in the look, feel, and quality of your images than the actual camera body itself does. It sounds crazy, doesn't it? But it's true—and learning what to look for in a lens (and what all those numbers on it mean) will serve you well. That way, you'll understand what it is that you already have, and you can dream about what you might want to get the next time you're in a camera store.

PORING OVER THE PICTURE

One of my favorite things about wide angle lenses is how big and vast they make things look and feel. Here, Haystack Rock of Oregon's Cannon Beach appears dramatic while cast against a soaring sky and expansive foreground.

The wide angle and low point of view combine to give this image a powerful presence.

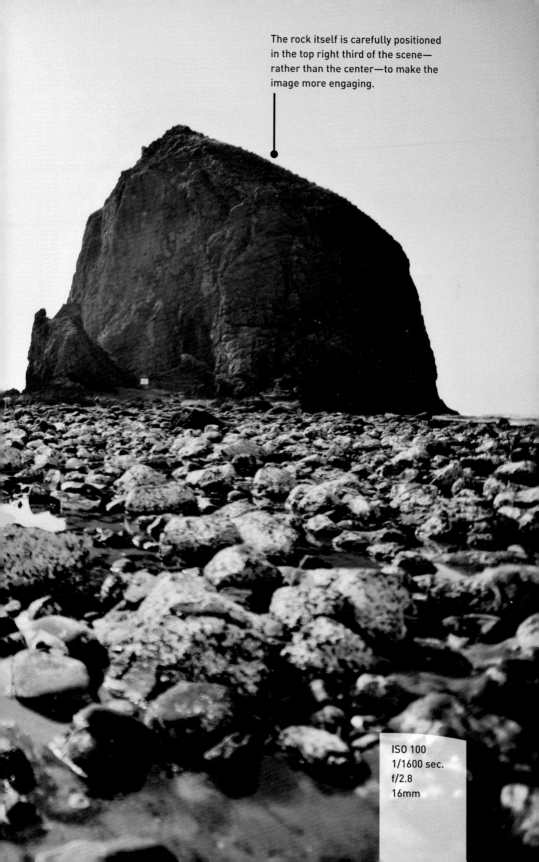

The rock itself is carefully positioned in the top right third of the scene—rather than the center—to make the image more engaging.

ISO 100
1/1600 sec.
f/2.8
16mm

WHAT'S WITH ALL THOSE NUMBERS?

When you look closely at a lens, there's a fair amount of numbers printed on either the front of the lens itself (**Figure 4.1**) or somewhere around the rim (**Figure 4.2**)—and though it may seem like a bunch of mumbo jumbo, it's actually pretty important info and can tell you a lot about the lens and what it's capable of.

FIGURE 4.1
Lens information is generally found around the front of built-in lenses.

FIGURE 4.2
Interchangeable lenses usually feature the lens information around the rim.

FOCAL LENGTH

The first number, or set of numbers, you see on your lens refers to its "focal length," measured in millimeters (mm). Roughly translated, focal length relates to how close up or far away objects will appear when viewed through the lens. Essentially, the bigger the number, the more up close subjects will appear, and the smaller the number, the farther away things will appear.

To give you a better idea of how this all plays out in real life, look at **Figures 4.3–4.7** and note the various focal lengths used to create each image. Photographed from the same position, the only difference between each shot is the focal length.

Lenses with focal ranges of 35mm or smaller are generally considered "wide," and lenses with focal lengths of 85mm or more are often referred to as "telephoto." A lens around 50mm is roughly close to the way we see things with our eyes and is generally considered neither wide nor telephoto. It is often referred to as "normal" or "standard."

ISO 200
1/320 sec.
f/8
16mm

FIGURE 4.3
Captured with an extremely wide focal length of 16mm, the scene appears very far away.

ISO 200
1/250 sec.
f/8
35mm

FIGURE 4.4
Shot at a focal length of 35mm, from the same position, the scene appears closer than before.

ISO 200
1/250 sec.
f/8
50mm

FIGURE 4.5
A focal length of 50mm brings the scene even closer.

ISO 200
1/250 sec.
f/8
70mm

FIGURE 4.6
The scene appears slightly closer again with a focal length of 70mm.

ISO 200
1/160 sec.
f/8
200mm

FIGURE 4.7
The same scene, captured with a telephoto focal length of 200mm, appears dramatically closer than before.

A single number, such as 24mm, represents what's known as a prime or fixed lens, meaning that it's not capable of zooming. Such a lens is designed and optimized for only a single focal length—in this case, 24mm.

A range of numbers, expressed with a dash such as 70–200mm, indicates a zoom lens, capable of different focal lengths—in this case ranging from 70mm to 200mm.

The bottom line? Depending on your camera body (see the "Crop factor" sidebar), you may be able to get the close-up shots you've always dreamed of without having to pay for a super telephoto lens. In some cases, your 200mm lens might behave like a 300mm lens. Now that's some serious bang for your buck!

Of course, if your camera has a smaller sensor and you like to shoot at a lot of wider angles, the opposite would also be true. The 24mm lens you loved at the camera shop might behave like a 36mm lens on your camera body, meaning you'd need an ultra-wide lens to get a standard wide-angle shot.

CROP FACTOR

Depending on the camera body you have, you may have experienced or heard people talk about something known as "focal length crop factor," "focal length multiplier," or even just plain ol' "conversion factor." While this may, at first, seem confusing, it's really quite simple and can sometimes be advantageous.

Back in the glory days of 35mm film, it didn't matter what camera body you used; as long as you were shooting 35mm film, the negatives were all the same size.

These days, film has been replaced by digital sensors, and as luck would have it, they're not all the same size. There's a lot of math and science involved in the full explanation, but essentially, the discrepancies in sensor size are responsible for what we now refer to as "crop factor."

The result? Everything appears closer when shot on a camera body with a sensor that's smaller than traditional 35mm film. Thus, a 50mm lens attached to a camera with a full-size sensor (referred to as full-frame) will behave like a regular 50mm lens. But the same lens on a camera with a smaller sensor (sometimes referred to as a cropped sensor) will be more like a 75mm lens.

Confused? For a visual explanation, take a look at **Figure 4.8** to see how your lens views the world. The large box displays the image as it would be captured on a full-frame sensor, and the smaller box shows how the scene would be captured on a smaller-sized sensor. Same scene, same lens—different effective focal length.

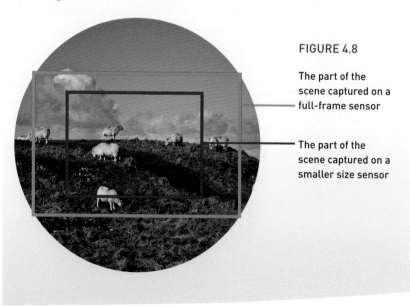

FIGURE 4.8

The part of the scene captured on a full-frame sensor

The part of the scene captured on a smaller size sensor

To determine your camera body's crop factor, you'll have to read some of the techno babble in your user guide or jump online and look it up. Crop factor is typically listed among all the other tech specs related to your camera and usually has a value of something like 1.3, 1.5, or 1.6.

For the sake of example, let's say your camera's sensor has a crop factor of 1.5, and you're curious how a 50mm lens would behave on it. To figure it out, take 50 (the focal length of the lens in question), multiply it by 1.5 (your camera's crop factor), and you get 75. Thus, on your particular camera, a standard 50mm lens would behave like a 75mm lens.

It's worth pointing out that some lenses are made specifically for cameras with smaller-sized sensors and have focal lengths that have already been converted. When in doubt, read the specifications or ask a knowledgeable salesperson.

MAXIMUM APERTURE

In Chapter 1, we talked about aperture and the role it plays in creating an exposure (keeping in mind that aperture is a function of the lens itself, not the camera body). Similar to the pupil of your eye, the aperture can dilate or constrict, letting in varying amounts of light and affecting the depth of field.

Appearing on your lens right next to the focal length, you will find a numerical expression representing the maximum (largest) aperture opening that particular lens is capable of, usually expressed as "1:" followed by the maximum aperture. For example, a lens described as a 24mm 1:2.8 would be a fixed lens with a focal length of 24mm, whose largest aperture setting is f/2.8. The lens is still capable of smaller apertures (like f/11), but the largest it would be capable of is f/2.8.

If you've spent time shopping for lenses, you may have noticed that a lot of zoom lenses feature not a single maximum aperture but, rather, an aperture range. If you have a lens that says 24–150mm 1:3.5–5.6, it means the lens is a zoom lens with focal lengths ranging from 24–150mm, whose maximum aperture varies depending on where you are within the zoom.

Depending on where you are within the zoom? What in the world does that mean? For example, if you're zoomed all the way out wide to 24mm, you could achieve a maximum aperture of f/3.5. But once you zoom in, you lose the ability to open up your aperture all the way to f/3.5 as before and can then only open to f/5.6.

Lenses with larger maximum apertures (generally 2.8 or larger) are often referred to as being "fast" because the larger apertures allow more light to reach the camera sensor, letting you shoot with faster shutter speeds in low-light situations where you might otherwise need a tripod. (Remember, larger apertures are actually smaller numbers; thus, f/2.8 is a larger aperture than f/8.)

MACRO LENSES

While some lenses may not be able to focus on anything closer than 18 inches (or more) from the front of the lens, "macro" lenses allow you to get much closer to your subject, helping you capture extremely close up and detailed shots (as seen in **Figure 4.9** and **Figure 4.10**) that simply wouldn't be possible otherwise. With a much closer "minimum focusing distance," macro lenses can open up a whole new photographic world.

ISO 400
1/125 sec.
f/4
100mm

FIGURE 4.9
The small minimum focusing distance of a macro lens allows you to shoot
from a very close range, rendering images not possible with other lenses.

ISO 1000
1/100 sec.
f/2.8
100mm

FIGURE 4.10
Flowers are popular subjects for macro photography.

Now that you understand focal length, your camera's crop factor (if it has one), and maximum aperture, you're set to give the salespeople a run for their money the next time you're at the camera shop!

MACRO MODE ON POINT-AND-SHOOT CAMERAS

As you saw in Chapter 2, many point-and-shoot cameras feature a built-in macro function, enabling you to get away with some pretty impressive minimum focusing distances without a dSLR or dedicated macro lens. Cool!

POINT-AND-SHOOT LENSES

Those of you with point-and-shoot cameras thought you got off easy on this one, didn't you? Just because your lenses are permanently attached doesn't mean there aren't a few things worth knowing. Focal length, zoom, and the ever-troublesome digital zoom are all important factors to know and understand when comparing one point-and-shoot camera to another.

FOCAL LENGTH AND ZOOM

Just as on the interchangeable lenses made for dSLRs, the focal length on your built-in lens is measured in millimeters, but the scale is dramatically different. The built-in lens likely has a focal range with smaller numbers than you would expect to find on dSLR lenses. For example, the focal length of the lens on one of my point-and-shoot cameras is 6–22.5mm (which works out to a dSLR equivalent focal range of something like 28–105mm). Because of the difference in scale, you can't compare the numbers at face value, but the principles still apply. Smaller numbers mean wider focal lengths, and larger numbers mean more telephoto focal lengths.

What you're really looking for when it comes to the built-in lens on a point and shoot is the range between the two numbers. The larger the range, the more pronounced your zooming capabilities are. The shorthand way of communicating this is by assigning your camera an "x" zoom number.

If the lens can zoom from 5–25mm, it's said to have 5x zoom. Or, as in my point and shoot's case, 6–22.5mm is the equivalent of a 3x zoom. The higher the x value, the greater the zoom range.

DIGITAL ZOOM—JUST SAY NO!

TV crime dramas would lead us to believe that digital zoom is the cat's meow. Even my beloved "Law & Order SVU" makes me giggle when super-zoomed, pixelated security camera footage shot from 300 yards away (in the dark) is analyzed, cropped even closer, then suddenly—as if truly touched by magic— becomes crystal clear, revealing an identifiable birthmark behind the criminal's left ear (cue the music).

Manufacturers have been known to make desperate attempts to seduce you with seemingly impressive features like "digital zoom." Nothing more than glorified in-camera cropping, it's actually one of the worst things you can do to your photos (as you'll see in Chapter 6).

Also measured with an x number (3x, 5x, or more), digital zoom picks up where optical zoom (what your lens is inherently capable of) leaves off, allowing you to zoom further than nature intended. To give you an example, I captured **Figure 4.11** by zooming the lens as far as optical zoom would let me go.

Figure 4.12 shows how much closer digital zoom allowed me to get. A pretty dramatic difference, isn't it? The trouble is it's actually quite misleading.

ISO 80
1/125 sec.
f/5
23mm (105mm)

FIGURE 4.11
These Colorado mountains were captured at the furthest extent of my point and shoot's optical zoom capabilities.

ISO 80
1/250 sec.
f/5
23mm (105mm)

FIGURE 4.12
This shows the same scene captured by maxing out my digital zoom. That's a pretty ginormous difference, wouldn't you say? As you'll see in Chapter 6, it's not healthy for your photos to be enlarged this way.

If you look at the metadata (digital photo guts) for this image, you can see proof that both images were actually captured at the same focal length. Digital zoom only makes it look like Figure 4.12 was photographed at a greater focal length. In reality, it's just a digital enlargement of the optical image captured by the sensor. Unfortunately, the quality is not the same as if the image had been captured optically, instead of with digital zoom.

Thankfully, many point-and-shoot cameras have the option to turn off digital zoom to avoid accidentally employing it. If your camera is one of these, I highly recommend it as digital zoom can be a serious-quality buzz-kill (especially if you continue the bad habit of further cropping your photos in post-production).

DIGITAL ZOOM: SO BAD YOU CAN TASTE IT?

Okay, so maybe you can't taste it, but you can actually feel it. To get a sense of what digital zoom feels like before banishing it to oblivion, zoom your lens out to the widest possible focal length. Then, carefully watch the image on your LCD screen as you slowly start zooming in.

You'll probably feel the camera pause when your lens reaches the extent of its "optical zoom" capabilities. It literally shifts gears and continues forward into "digital zoom" territory, where you'll notice the image becomes pixelated and takes on a look that can only be described as digital. Ech.

This is where we part ways with what we see on the TV crime dramas. Detectives Benson and Stabler may catch a break when their lab techs magically turn pixelated security footage into gold for the prosecution, but when it comes to our cameras (and a little place I like to call reality), we're stuck with the garbled aftermath known as digital zoom.

Protect yourself and practice safe zooming. If you're not sure how to shut off digital zoom, cozy up to your user guide to find out.

SHOPPING FOR LENSES

In addition to focal length, maximum aperture, and minimum focusing distance, lenses can vary by size, shape, weight, the material they're made of (plastic or glass), advanced features such as "vibration reduction" (to help with stabilization), and even their ability to auto focus (not all lenses can, so don't assume). As you can see in **Figure 4.13**, lenses can also vary in color!

Of course, all these variables also mean lenses can range dramatically in price, starting anywhere from around $50 to well over $25,000 each. Generally speaking, the larger the maximum aperture value and the greater the focal length, the more expensive the lens tends to be.

FIGURE 4.13
Various lenses range in size, shape, color, capability, and price.

When trying to figure out which lens is right for you, ask yourself the following questions:

- What kinds of things do you plan to photograph? Do you like to shoot portraits, or are you more of a landscape person?

- What kind of environment will you most likely be photographing in? Do you tend to shoot in bright, outdoor situations? Or are you more often in darker, low-light environments?

- Do you need a collection of specialty lenses with very wide apertures or maybe a macro lens? Or would a more general, multipurpose lens be a better fit?

- Do you always find yourself zooming in and wishing you could get even closer? Or do you prefer the look of images shot at wider focal lengths?

If you tend to do a lot of shooting when you travel, be sure to consider the impact that carrying around multiple lenses might have on your mobility. I've found that, in many cases, the more gear I take with me on personal trips, the less I end up shooting because carrying everything around is often a royal pain (you may have noticed that most of the travel photos seen in this book were captured with a compact point-and-shoot camera).

Striking a balance between having the right gear for the occasion while still feeling comfortable is often the key.

Chapter 4 Assignments

What's Your Glass?

Take a look at your lens (or lenses) and be sure you understand what you've got. What's your focal length range, or do you have a prime lens? What's your maximum aperture? Does it depend on how much you've zoomed the lens in or out?

Banish Digital Zoom!

If you use a point and shoot, I recommend that you take the time right now to dig into your settings and turn it off. Though it can be very tempting to use the digital zoom, it does nothing but harm to your images. If you need to get closer to something, go old-school and "zoom with your feet"!

Seeing the Range of Possibilities

If you are working with a zoom lens, head outside and take a series of shots, from the widest angle that your lens is capable of, through the mid-range of your lens, all the way out to where your lens is maxed out. Take a look at all of those images and consider the range of shots your lens gives you. Cool, right?

Share your results with the book's Flickr group!

Join the group here: flickr.com/groups/gettingstartedfromsnapshotstogreatshots

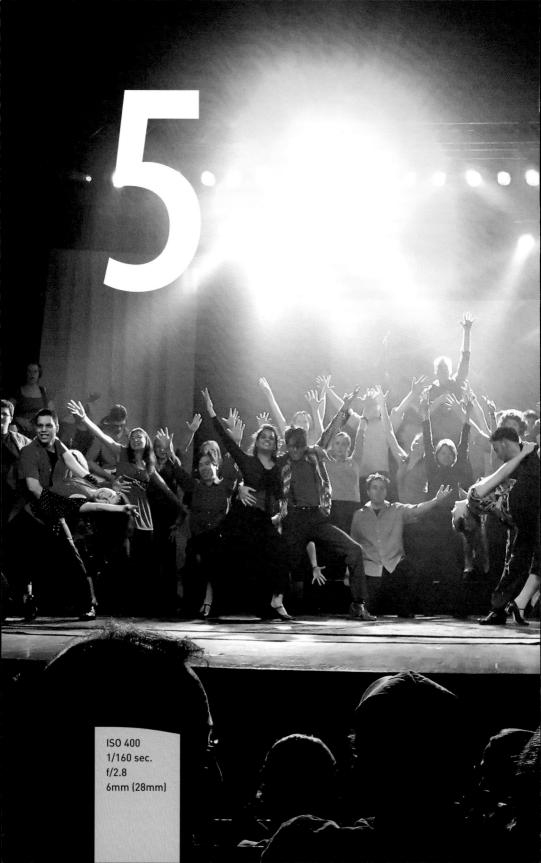

5

ISO 400
1/160 sec.
f/2.8
6mm (28mm)

Rock That Camera!

REAL-WORLD PROBLEM SOLVING

Are ya feelin' it? Now that you understand the basics of exposure, the different shooting modes, and all those great functions, there's a whole new world of better photos waiting for you! But how do you really pull it off? How do you work your way from an image that isn't working to a better one that makes your heart happy?

When you take a photo and it's not what you hoped for, the old you may have gotten frustrated and uttered a few choice words at your camera before shrugging your shoulders and surrendering to the false hopes of a newer model. The new you knows better. When things don't go your way, the solution is actually pretty simple: plain, old-fashioned problem solving.

PORING OVER THE PICTURE

Who says you have to have a big fancy studio to get great images? With a little know-how and a dash of determination, you can pull off impressive images most anywhere!

While visiting my sister Gina's house, I wanted to capture a portrait of her and my nephew Dominic, but good light was short on supply. Rather than blasting the scene with on-camera flash or declaring the house too dark and missing out on a great moment, I simply asked them to snuggle up right next to the large window in the living room. With the flash suppressed, I captured this image on my trusty point-and-shoot camera using only natural light.

Look closely and you can see the reflection of the window in Dominic's eyes.

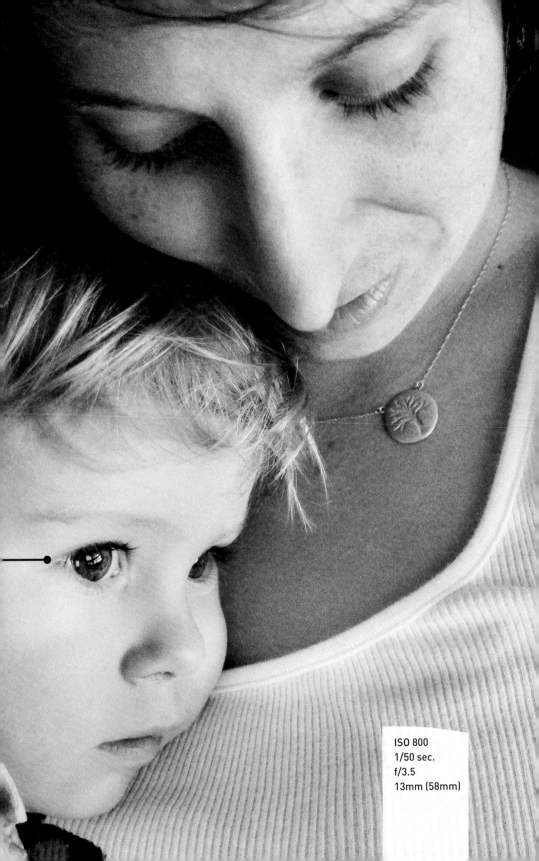

ISO 800
1/50 sec.
f/3.5
13mm (58mm)

IDENTIFYING THE CHALLENGE

When you take a picture that isn't quite what you wanted, instead of looking at the back of your LCD screen and declaring your utter disgust, take a moment to pause and name the problem—with actual words.

- **Don't say** "This image is total garbage. My camera is a piece o' junk!"

- **Do say** "Hmm, my moving subjects look blurred and the color is wacky."

See the difference? The first option is an ambiguous declaration you can't do much about, but the second statement clearly identifies the problem and, in doing so, practically leads you straight toward a solution.

Once you have a well-defined problem, solving it becomes infinitely easier. You simply follow your definitive statement with a definitive solution. In this case you might tell yourself, "I'll try increasing my shutter speed and changing the white balance." Bam! It's that easy.

The process for any situation is roughly the same:

1. Shoot some images.

2. Evaluate them. Are they what you hoped for? If not, why not? Use words to specifically define the problem you're having. If you had to explain the problem in a single sentence to a friend, what would you say?

3. Take steps to correct it.

This chapter will take a look at four common scenarios and the challenges they present. Instead of offering only a single solution, we'll explore several options for overcoming each challenge.

Why not just make it easy and offer a one-size-fits-all solution, you ask?

The truth is there isn't one. If you really want to get good at bossing your camera around, you'll have to learn to adapt. Every situation is different, and as in any grand adventure, there are no guarantees.

So instead of arming you with a solution that works only under very specific circumstances, this chapter will teach you to understand the challenge you're facing, as well as the options for overcoming it, thereby empowering you to find success in most situations—not just the examples presented here.

To get started, you'll have to accept the fact that there's no such thing as a foolproof field guide, flow chart, or recipe for every scenario. Every choice you make will have advantages and disadvantages because, as far as I know, there's not a single camera on the planet with a magical "make it all better" button.

Ultimately, experimentation and practice will be your best defense against whatever challenges come your way.

CHALLENGE: BACKLIT SITUATION

Any time the area behind your subjects is more brightly lit than they are, you're in a backlit situation. When the camera calculates the exposure for such a situation, it doesn't know if you're trying to take a photo of the bright background or the people standing in front of it. The camera looks at the scene and thinks, "Wow, good thing there's so much light—no need for me to fire the flash!"

The result is often a photo like **Figure 5.1**, where the bright background looks good but the subject is too dark (underexposed).

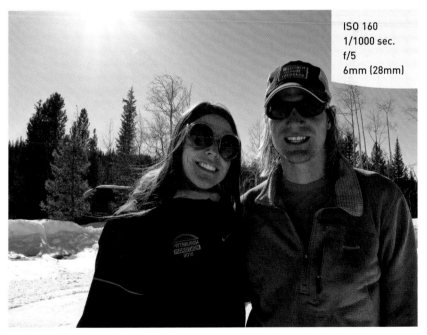

ISO 160
1/1000 sec.
f/5
6mm (28mm)

FIGURE 5.1
The bright sun and snow behind Christina and Jason factored too heavily into the camera's exposure calculation, resulting in settings that left the cute couple in the dark (underexposed).

FIX IT WITH FILL FLASH

- **Pros:** Properly exposed subject and background.

- **Cons:** Might change the look/feel of the image.

Dig into your settings to turn on your fill flash. This will force your flash to fire, better illuminating your subject, as seen in **Figure 5.2**.

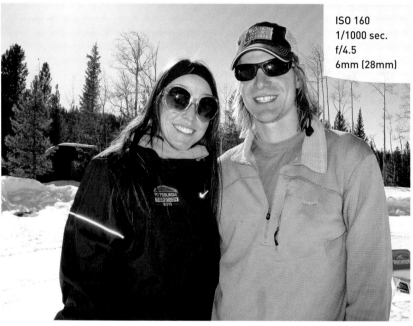

ISO 160
1/1000 sec.
f/4.5
6mm (28mm)

FIGURE 5.2
Fill flash balances the exposure between the bright background and the darker subjects.

REPOSITION YOURSELF (OR THE SUBJECT)

- **Pros:** Properly exposed subject and background, all natural light.

- **Cons:** Possible shadows or squinting.

If you look closely at Figure 5.2, you'll notice that although the flash fixed the exposure issue, it created a new problem by causing a distracting reflection off the material in Christina's jacket (not to mention their sunglasses).

Preferring the look of natural light to that of direct flash, I simply turned around to put the sun over my shoulder (instead of in front of me as it was before) and asked Christina and Jason to move over a few feet and turn toward me. Because they were wearing sunglasses, I didn't have to worry

about the sun causing them to squint and was able to capture a more natural-looking image, seen in **Figure 5.3**.

Even though the new position caused Jason's hat to cast a shadow on his face, the snow helped soften it by bouncing sunlight off the ground and back into his face, brightening what would've otherwise been a dark shadow.

By placing the sun over my shoulder (instead of in front of me), I was also able to capture the more dramatic blues of the sky. Pretty sweet trick, eh?

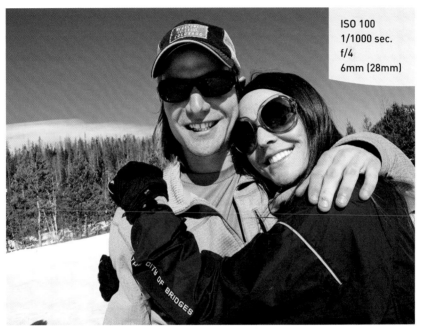

ISO 100
1/1000 sec.
f/4
6mm (28mm)

FIGURE 5.3
Without flash, I was able to even the exposure between my subjects and the background by repositioning myself so the sun was over my shoulder instead of in front of me, resulting in a more natural-looking image.

REACH FOR EXPOSURE COMPENSATION

- **Pros:** All natural light.

- **Cons:** Background will become overexposed.

If you generally prefer the look and feel of natural light, you'll be happy to know that there are additional flash-free alternatives, even for those times when repositioning yourself (or your subject) isn't an option.

As discussed in Chapter 3, you can use exposure compensation to brighten your subject while letting the brighter background behind them blow out (become overexposed), as seen in **Figure 5.4.**

ISO 800
1/125 sec.
f/2.5
50mm

FIGURE 5.4
If you prefer the look of natural light, you can use exposure compensation to deal with backlit situations as long as you don't mind severely overexposing the background. In this example, choosing to expose the subject correctly meant letting the bright scene outside the window blow out (severe overexposure).

To pull it off, make sure you're in a shooting mode that gives you the freedom and flexibility to tweak your exposure compensation settings (something like program mode), then experiment to find the best results. A setting of +1 might be a good place to start. Take test shots and continue to adjust as needed.

The goal is to increase the overall exposure so that your subject will be properly exposed even though your background will continue getting brighter and brighter, eventually blowing out completely and becoming pure white.

Many cameras will even preview the adjustments on your LCD screen as you make them, so you can get a feel for what's happening before you take the photo.

TRY SPOT METERING MODE

- **Pros:** All natural light.

- **Cons:** Background will become overexposed.

If you max out your exposure compensation range (meaning that you've set exposure compensation to +2 and your subject is still too dark), you could try changing to "spot metering mode."

As you may recall from Chapter 3, spot metering mode calculates exposure based on a very specific portion of the scene (like your subject's face) rather than by averaging the whole scene together as the default metering mode (evaluative) does. Because of this, spot metering mode makes it possible to nail the exposure for a certain part of the scene—even if it's dramatically different from the exposure in the rest of the scene.

Once you've switched modes, place your subject in the center of the frame and press and hold the shutter button down halfway. Then, while continuing to hold the shutter button halfway down, recompose the scene the way you want and finish by pressing the button the rest of the way down to take the photo.

Using spot metering mode to achieve proper exposure on your subject while overexposing the background would give you the same results seen in Figure 5.4.

MAKE FRIENDS WITH MANUAL MODE

- **Pros:** Full control to get the shot the way you want it.

- **Cons:** Not every camera offers manual mode.

As mentioned in Chapter 2, with practice, manual mode can actually be faster, easier, and more successful at helping you get what you want than any

other mode. So if you think monkeying around with metering modes and exposure compensation sounds like a hassle, switch to manual mode, choose your settings, and take a few test shots. Adjust as needed.

Keep in mind that if you choose to keep your flash off, you'll be purposefully overexposing the background, so don't panic if your light meter is indicating overexposure. Base your exposure on how your subject looks in test shots rather than what the light meter says about the overall scene.

CHALLENGE: STAGE LIGHTING

Even though it's typically pretty dark at your child's dance recital or theater performance, the flash is usually more problematic than it is helpful (see **Figure 5.5**). Though not capable of lighting up the whole stage, it does do a pretty great job of lighting the heads of the people seated in front of you!

ISO 250
1/80 sec.
f/2.5
7mm (33mm)

FIGURE 5.5
Look familiar? Not only is the flash distracting to performers and other audience members, but it does nothing more than light up the heads of the people sitting in front of you. Get rid of it!

Rather than letting it continue to disappoint you, tell it to take a hike! The results, often much more rewarding, can be seen in **Figure 5.6**.

ISO 125
1/40 sec.
f/2.5
7mm (33mm)

FIGURE 5.6
Canceling the flash not only got rid of the heads of the people in front of me, but also resulted in more accurate color.

KILL THE FLASH

- **Pros:** No more distracting flash!

- **Cons:** Um...you might have a hard time choosing between all the improved photos you get?

In a flexible shooting mode other than auto, cancel your flash, and check your ISO menu settings to make sure the camera has free access to higher ISOs to compensate for such a dark shooting environment. If your camera lets you set a specific ISO, try something like ISO 1000. If your camera offers only a range of ISO, such as normal and high, set it to high.

Once you've canceled the flash, you won't have to worry about illuminating the heads of the folks in front of you, and because you've jacked up the ISO, the camera can compensate for the low light without resorting to crazy slow shutter speeds (which could otherwise result in blurred photos).

But even with a high ISO, there may still be some scenes (depending on light-ing conditions and the stage action) when it might be tricky to get a sharp shot without a tripod. To pull it off, practice stabilizing your arms by bracing

your elbows on the arm rests of your seat or on your lap, or simply by tucking them in against your ribs. Hold your breath and fire away.

If things aren't as sharp as you'd like, try bumping the ISO higher (if you can), and take some additional test shots. If still no luck, keep your camera ready and wait for a moment in the production where the stage is especially bright or the action is holding still (a finale of some sort, perhaps?) and focus your attention there for better odds.

Remember that dramatic lighting on the stage can create areas of extreme brightness next to areas of total darkness, so if you're having exposure problems, play around with exposure compensation and consider using spot metering mode *instead of defaulting to the evaluative metering mode.*

FLASH AND COLOR TEMPERATURE

Because the color temperature of your flash is quite different from that of the stage lights, turning it off might also result in more accurate color. Bonus!

KILL THE FLASH AND PICK YOUR OWN SHUTTER SPEED

- **Pros:** No more distracting flash and better blurriness prevention.

- **Cons:** Not available on every camera.

After killing the flash, you may find that you get even better results by switching your shooting mode to shutter priority so you can prevent blur by choosing your own shutter speed.

In a dark shooting environment like the theater, you can help your camera out by choosing the slowest shutter speed that successfully prevents motion blur. It's best to start with a shutter speed of around 1/60 and increase it as needed, rather than beginning with something like 1/4000. This way, you'll avoid having to use extremely high ISO values to compensate for unnecessarily high shutter speeds.

If the action on stage is too fast for a slower shutter speed like 1/60, try successively faster shutter speeds until you find one that freezes the action. Just make sure your ISO setting is unrestricted so the camera can compensate as needed.

Don't forget that you can tweak the overall exposure using exposure compensation or create a more targeted exposure using spot metering mode.

KILL THE FLASH AND GET TOTALLY BOSSY

- **Pros:** No more distracting flash and full control over exposure settings.

- **Cons:** Not every camera offers manual mode.

Anytime you get frustrated with the results you're getting in other modes, remember that manual mode isn't as scary as you may think and, with practice, can actually be faster and more reliable than anything else for getting the shots you want.

In a dark environment like a theater, I'd recommend building your exposure equation around whatever shutter speed allows you to get a sharp shot. A setting of 1/60 might be a good place to start.

Once you've got your shutter speed nailed down, choose a large aperture (small number), and play around with your ISO until your test shots look good. If the scene is blurred, bump your ISO higher and choose a faster shutter speed.

Because of the dramatic lighting of the stage, your light meter might be jumping all over the place and may not accurately reflect a proper exposure. You can switch to spot metering mode if you like, but either way, make sure to take plenty of test shots to help you find the exposure settings you like best, rather than obsessing too much about what the meter says.

CHALLENGE: NIGHT SCENE

Any time you're photographing a dimly lit subject in a dimly lit environment, the potential exists for your subject to appear surrounded by a black hole. The problem in these types of situations is the difference between what the exposure will be on your subjects (when the flash goes off) compared to the dark background, stretching beyond your flash's range, as in **Figure 5.7**.

The solution is to force the camera to choose a slower shutter speed, giving the background a chance to be recorded. **Figure 5.8** shows the difference a slower shutter speed can make, and as luck would have it, there are several ways to make it happen.

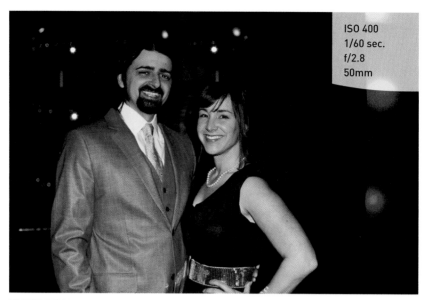

ISO 400
1/60 sec.
f/2.8
50mm

FIGURE 5.7

In auto mode, a shutter speed of 1/60 makes the background look dark and dull.

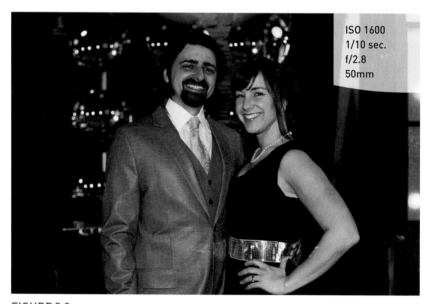

ISO 1600
1/10 sec.
f/2.8
50mm

FIGURE 5.8

Forcing the camera to use a slower shutter speed of 1/10 allows the colorful background to be recorded.

USE NIGHT PORTRAIT MODE

- **Pros:** Easy way to improve your photos in a nighttime/dark environment.

- **Cons:** Unable to select a specific shutter speed; you have to let the camera choose.

This is the kind of thing night portrait mode was made for! The flash will be enough to light the subjects, and the reduced shutter speed will give the darker background a fighting chance. You may not achieve perfection, but odds are it's an improvement.

Some cameras keep night portrait mode mixed in with the flash settings instead of alongside the shooting modes. In some cases, it may be referred to as slow-sync flash.

DRAG YOUR OWN SHUTTER

- **Pros:** Ability to select a specific shutter speed for greater control.

- **Cons:** Not all cameras feature shutter priority mode.

Did you know that any time you add flash to your photos you can control how bright the background looks in comparison just by adjusting the shutter speed? It's true, and the results can be pretty amazing. All you need to know is

- Slower shutter speeds = brighter backgrounds.

- Faster shutter speeds = darker backgrounds.

Because night portrait mode doesn't let you choose a specific shutter speed, the extent to which it can affect your photos is limited. Switching to shutter priority mode will give you additional flexibility by letting you slow the shutter down as much as you want, referred to as "dragging" your shutter.

To try dragging the shutter for yourself, confirm that your shooting mode is set to shutter priority, and make sure your flash is on and ready to fire. It should fire automatically in this type of situation, but if for some reason it doesn't, you can force it to by turning on your fill flash.

Experiment with slower shutter speeds like 1/15 or 1/10. Take some test shots and pay special attention to how the background is being recorded. If the background is still not as bright as you'd like it to be, slow the shutter speed down even more, then try again. If the background becomes too bright, choose a faster shutter speed.

STABILIZING THE SHOT

When using flash in dark situations like this, you may notice that you can hand-hold the camera at slower shutter speeds than usual. But eventually, if you slow the shutter speed far enough, you may want to stabilize the camera. Look for a ledge/wall/chair to balance the camera on and consider using the 2-second setting on your built-in self-timer to avoid camera shake from pressing the button.

DRAG YOUR OWN SHUTTER IN MANUAL MODE

- **Pros:** Ability to select a specific shutter speed, ISO, and aperture for total control.

- **Cons:** Not all cameras feature manual mode.

Using manual mode, set your ISO somewhere in the range of 800 to 1600, choose a fairly large aperture such as f/4 or greater (remember that smaller numbers actually mean larger apertures), and try a shutter speed of 1/15.

Take a test shot and examine the background. Adjust your settings as needed, keeping in mind that slower shutter speeds make the background brighter and faster shutter speeds make it darker.

CHALLENGE: INDOOR SPORTING EVENT

You know what I'm talking about—those dimly lit gymnasiums that seem to foil your every attempt at a decent photo. As seen in **Figure 5.9**, the problems are nearly the same every time: blurriness with a tinge of yellow.

As you learned in Chapter 1, time and movement are controlled by shutter speed. Thus, when you see blur like in Figure 5.9, it's a sign that the subject is moving too fast for your current shutter speed.

Auto mode is a toss-up when it comes to sports photos, but luckily you have other options. That yucky yellowish color means auto white balance is missing the mark, and you'll need to try something else.

The following list of potential solutions will help you find your way to a sharper image with better color, as seen in **Figure 5.10.**

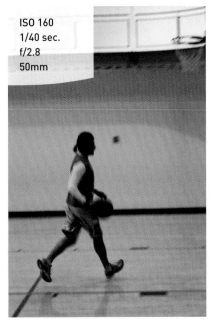

ISO 160
1/40 sec.
f/2.8
50mm

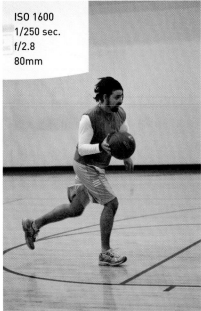

ISO 1600
1/250 sec.
f/2.8
80mm

FIGURE 5.9
Captured in auto mode with a shutter speed of only 1/40, this photo is typical of images from indoor sporting events: blurry with a tinge of yellow.

FIGURE 5.10
A faster shutter speed of 1/250 froze the subject while the fluorescent white balance option was a better match for the light in the gymnasium.

SWITCH TO SPORTS MODE

- **Pros:** Little to no thinking required.

- **Cons:** You can't set a specific shutter speed, and you may have limited access to white balance settings.

Switching to sports mode will not only help you get a faster shutter speed; it may also give you the ability to track moving subjects (using servo or continuous focus modes as discussed in Chapter 3) and shoot a burst of images in a row (with continuous drive mode, also covered in Chapter 3).

Keep in mind that in order to pull off a faster shutter speed, the camera will need to compensate for the reduced light in one way or another, and the options will be limited if the higher range of your ISO is restricted. So check your menu settings to make sure you haven't restricted your camera from reaching higher ISOs. The higher you let the ISO climb, the faster the shutter speed you can get away with.

To fix the color problems, you'll need to tinker with your white balance settings. Gymnasiums are typically lit with some form of fluorescent light, so one of the fluorescent settings would be a good place to start. Make the change, take some test shots, and you should be ready to roll. If the color in your images is a severe problem, and your camera's version of sports mode doesn't let you change your white balance, you'll need a different solution.

TRY PROGRAM MODE

- **Pros:** Little to no thinking required, access to white balance settings, available on almost all cameras.

- **Cons:** No way to directly influence the shutter speed, can be kind of a toss-up.

If your camera doesn't offer sports mode (or any type of kids & pets mode), or if you're unable to access your white balance settings while in sports mode, try a mode like program where the camera still does the heavy lifting but you can boss it around in some ways.

Unlike in sports mode, where the camera knows you're shooting action and can respond with a faster shutter speed, in program mode the camera doesn't know what type of shooting scenario you're in, so you can't count on it to be as helpful.

In this case, you can try to make the camera choose a faster shutter speed by shifting the exposure equation to include a more sensitive (higher) ISO, thereby forcing the camera to compensate with a faster shutter speed (though it might choose to compensate with a smaller aperture instead).

It's something of a toss-up, but give it a shot by navigating to your ISO settings and choosing something quite high, such as 1200 or 1600. In the event that your camera has only two options (such as auto or high), set it to high. Once the blurriness is under control, attack the color issue by experimenting with other settings besides auto white balance (the fluorescent settings are a good place to start).

It might also be helpful to switch the focus mode to continuous (aka servo) to track moving subjects and the drive mode to burst (aka continuous) to shoot a series of images in rapid succession, increasing your odds of capturing all those critical moments.

EXPERIMENT WITH SHUTTER PRIORITY MODE

- **Pros:** Offers total control over shutter speed; provides access to white balance, focus, and drive modes; allows the camera to handle the rest of the exposure.

- **Cons:** Not available on every camera.

Shutter priority mode lets you freeze the action by choosing your own shutter speed (unlike sports or program mode when you can do little more than boost your ISO and cross your fingers).

The exact shutter speed required will ultimately depend on the speed of your subjects, as trying to freeze the motion of a sports car zipping by at 225 mph calls for a significantly faster shutter speed than a high school basketball player dribbling across the court (even if they're bound for the pros).

But where do you start?

- To get a high-quality image and avoid digital noise from unnecessarily high ISOs, you'll want to use the slowest shutter speed you can get away with while still freezing the action. For this reason, it makes sense to start on the slower end of the spectrum with a shutter speed like 1/250 instead of working backward from faster shutter speeds like 1/4000.

- If you start with 1/250 and the action is still blurred, progressively increase the shutter speed until you're able to freeze the action. The more you practice shooting the same scenes over and over, the better you'll get at guessing which shutter speeds will work best, and this whole process will become increasingly easier.

- The camera will have to compensate for the lost light caused by faster shutter speeds, so check your menu settings to make sure you're not preventing the camera from reaching upper-level ISO values.

- To keep the color in check, jump over to your white balance settings and dig around (likely starting with the fluorescent options) until you find the preset that gives you the best results.

- If you want to track your moving subjects or shoot a series of images in rapid succession, set your focus mode to continuous (aka servo) and the drive mode to burst (aka continuous).

CALL ALL THE SHOTS WITH MANUAL MODE

- **Pros:** Full control over all exposure settings, focus mode, and drive options.

- **Cons:** Not available on all camera models.

In the case of an indoor sporting event, I'd suggest starting with a base ISO of anywhere from 800 to 1200. Open your aperture as wide as possible (the smallest number), then look at your light meter and take some test shots to see what shutter speed makes for a good exposure. You'll need something in the ballpark of 1/250 to start, so if your meter (or test shot) indicates under-exposure, bump up your ISO even higher (1200+) and try again.

If the motion is blurred, pick a faster shutter speed and compensate with an even higher ISO. Take more test shots. Still blurred? Use an even faster shutter speed and an even higher ISO, and take test shots to confirm. Continue this process of tweaking your shutter speed and compensating with a higher ISO until you find a winning combination.

As with the other possible solutions, adjust your white balance to address any color issues, use continuous focusing (aka servo) to track moving subjects, and switch to continuous drive mode (aka burst) to shoot a series of images in rapid succession.

Chapter 5 Assignments

Embrace the Backlight

Head outdoors and place your subject between yourself and the sun. Using any number of the tactics we discussed here—fill flash, exposure compensation, spot metering, and even shooting in manual mode—explore your options and get comfortable shooting into the light.

Let the Light In

In a low-light or night situation, try using a slower shutter speed when your subject will be lit with flash to prevent the background from resembling a dark cave. Drag the shutter manually or use a preset like night portrait mode.

Action!

Head out to the park with some friends and a football or frisbee to grab some action shots. Get clearer, better shots by using a preset like sports mode or choosing a fast shutter speed of your own. Compensate for the lost light with a higher ISO, and choose an appropriate white balance for better color. Track moving subjects with continuous focus mode (aka servo) and use continuous drive mode (aka burst) to capture a series of images quickly.

Share your results with the book's Flickr group!

Join the group here: flickr.com/groups/gettingstartedfromsnapshotstogreatshots

ISO 50
1/3200 sec.
f/1.4
50mm

Clarification Station

RAW VS. JPG, PIXELS, RESOLUTION, AND DEATH BY CROPPING!

If you've talked to other shutterbugs, read most any photo magazine, or dug around deep enough in your camera's settings menu, chances are you've come across the option for capturing images in either RAW or JPG file formats. When you asked around, you got a smorgasbord of different opinions garbled together with only bits and pieces of an actual answer, leaving you more confused than before.

Or have you ever been confused by terms such as pixels, megapixels, and resolution? You're not alone. In this chapter, we'll tackle it all, including the one thing that can seriously spoil an image no matter how brilliant your timing or how well you nailed the white balance. It's known as—cropping (though, of course, not *all* forms of cropping are menacing). Let's discuss!

Sometimes, you just have to "dive in!" What visit to Miami would be complete without a trip to South Beach? Thanks to an underwater housing case for my old Canon PowerShot SD750, my husband Emir was able to snag this super fun shot

The tilted horizon line adds to the sense of playfulness and energy of this scene.

Getting up close to the action makes this photo much more compelling than if it had been shot from the sand.

ISO 80
1/640 sec.
f/8
6mm (28mm)

RAW VS. JPG

If you've never changed your settings, congratulations—you're shooting in JPG format. Before we go any further, you should know that, for most folks reading this book, there's no reason to switch. So if you're thinking, "What!? Now I have to worry about which *format* I shoot my photos in? Get me outta here," don't jump ship. Just keep on shooting JPGs, and you'll be fine.

However, because the goal of this book isn't just to tell you what buttons to push or which settings to use, but rather to help you understand why, I feel compelled to tell you the rest of the story.

By default, most cameras capture images in a file format called JPG (pronounced "jay-peg" and sometimes written as JPEG). Unless you've changed your settings, JPGs are what you find waiting for you on your camera's memory card. They're the files you download onto your computer, edit in various software programs, upload to sites such as Facebook or Flickr, and ultimately, they're what you send to the lab for printing. If the photography world had a common currency, JPG would be it.

Some cameras allow you the additional option of capturing your files in a different format called RAW. (Heck, some cameras will let you shoot in both formats at the same time!)

In the realm of professional digital photography, few things are as hotly debated as RAW versus JPG. Ask pro shooters where they stand, and you'll likely get very impassioned responses from both sides of the fence. The pendulum seems to have swung both ways over the years, ultimately coming down to personal preference and control more than anything else. If you put two high-quality, properly exposed photos side by side and tried to guess which one began life as a RAW file and which was born a JPG, you'd be hard pressed to see a difference. The debate isn't so much over the end result, but rather the process of how you get there.

WHY SOME FOLKS LOVE JPGS

JPGs are vastly embraced for a number of reasons, including the fact that they're entirely universal and are easily viewed by anyone on most devices with no special software required. Another thing that makes JPGs so beloved is their relatively small file size. An image captured as a JPG would take up considerably less disc space than if the same image had been captured in RAW—even though the number of pixels in each image would be exactly the same.

This makes for faster file transfers and gives you more bang for your buck when it comes to the number of photos you can fit on both your memory card and your hard drive. JPGs are also low maintenance. Once they're captured, they're ready for action and can be shared online, emailed to a friend, or sent directly to print with no additional work required. But of course, every yin has a yang.

FILE SIZE VS. IMAGE SIZE

The term "file size" is not to be confused with image size. File size refers to the amount of space the image file occupies on a disc or memory card, and image size refers to the image's pixel dimensions and resolution. Though a JPG has a smaller file size than a RAW file, the image size would be the same.

JPGS: FULL DISCLOSURE

It's true—not everyone loves JPGs as wholeheartedly as some people do, and the pesky double-edged sword known as compression is generally the culprit. On one hand, compression is what allows JPGs to be so fantastically lightweight when saved to your memory card or hard drive. On the other hand, the very nature of compression requires the sacrifice of quality in favor of a smaller file size, discarding small bits of information that would otherwise be included in the file.

Additionally, by the time JPGs find their way to your memory card, they've already been processed, not by you—by your camera. Each time you capture a JPG, the camera records the image along with a set of instructions for how to process it. In this sense, your camera acts like a chef, cooking your JPG while saving it to your memory card.

As seen in **Figure 6.1**, some cameras even give you the ability to specify the particular way your JPGs are processed. Depending on your model, you may be able to choose settings for things like sharpening, contrast, saturation, and color tone.

FIGURE 6.1
Some cameras give you the ability to specify the particular way your JPGs are processed.

While having your very own chef may sound pretty sweet, it doesn't come cheap! All the in-camera processing that takes place limits your options for further adjusting the file with editing software later (which is why it's so important to get it right in the camera). Because the processed and compressed pixels of a JPG don't contain as much image information as the pixels in a RAW file do, there's less cushion for adjusting things like white balance or exposure in post-production.

WHY SOME FOLKS LOVE RAW

As the name implies, RAW files are, well, *raw.* They are not processed or compressed by your camera. Because of this, RAW files are, in a word, huge. Taking up roughly four times as much disc space as JPGs, RAW files are the sumo wrestlers of file formats.

Even though they have the same number of pixels as their JPG counterparts, RAW files are significantly larger because they haven't been processed or compressed by the camera. Therefore, they retain all the extra information that is normally cooked out of a JPG (so to speak). The difference is that instead of having to settle for the way your camera processes, you get to wear the chef hat and cook the files yourself.

If you didn't quite nail the white balance or you botched the exposure a bit, you might be able to save the image in post-production. Because of the rich pixel data stored in a RAW file, there's greater latitude for adjusting the image after the fact.

SECOND THOUGHTS ON GOING RAW

Though getting to play chef with all your images may sound appealing at first, it can also mean significantly more work. Unlike JPGs that can be downloaded and immediately sent to a photo lab, printed at home, or shared online, RAW files aren't so agile. Even though they come out of your camera in an unprocessed format, they can't stay that way. Eventually, they'll have to surrender and be processed in order to be useful. (You can't send a RAW file to a photo lab for printing any more than you could upload a RAW file to Facebook.)

As the official RAW chef, you're the one responsible for cooking (processing) all those files, and though software can help, the bottom line is it's still more work for you. Here's the real kicker—once processed, RAW files must eventually be saved as one of several other file formats including, but not limited to, JPGs. Yep. You read that right. A bit paradoxical, isn't it?

THE VERDICT?

A hung jury. As it turns out, the debate of RAW versus JPG isn't about one format being better than another. It's about which format best serves your needs, and ultimately it comes down to personal preference, control, and overall convenience. For most people, JPGs are the way to go. Why not try 'em both and decide for yourself? A side-by-side comparison of the workflow associated with each format can be seen in **Figure 6.2**.

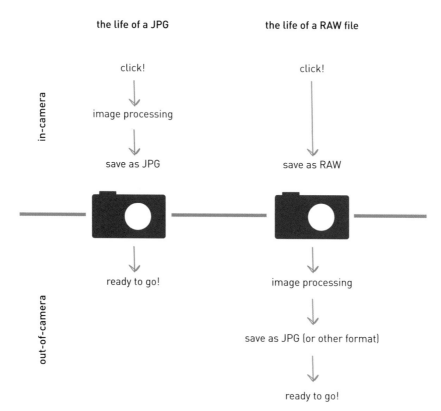

the life of a JPG

the life of a RAW file

in-camera

click!

↓

image processing

↓

save as JPG

out-of-camera

ready to go!

click!

↓

save as RAW

↓

image processing

↓

save as JPG (or other format)

↓

ready to go!

FIGURE 6.2
The workflow of JPG and RAW files compared side by side.

RESOLUTION REVELATION

Pixels, megapixels, and resolution: These words get thrown around a lot, but few people stop to think about what they really mean. Sounds like a resolution revelation is in order! Don't reach for your headache medicine just yet, folks; learning about pixels is easier than you think (seriously).

WHAT IS A PIXEL, ANYWAY?

Simply put, pixels are the building blocks of your image. In fact, the word "pixel" actually comes from the conjunction of two words: "picture" and "element." (If you're ever on "Jeopardy," you're welcome!)

If you were to zoom in on your photos on the computer, you'd see those pixels for what they are: magical little photo-licious squares. Like the tiles in a mosaic or the bricks of a house, pixels are the building blocks of a photograph, as seen in **Figure 6.3**.

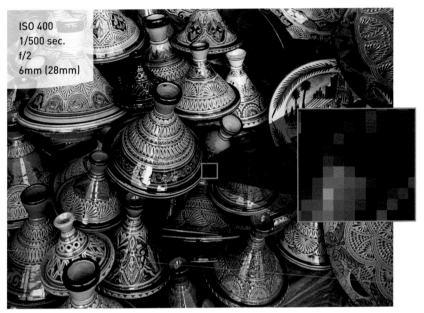

ISO 400
1/500 sec.
f/2
6mm (28mm)

FIGURE 6.3
Like the tiles in a mosaic or the bricks of a house, pixels are the building blocks of a photograph.

The total number of pixels an image has depends on the image-size settings of the camera used to capture it. A camera capable of producing images with 12 million pixels is said to be a 12-megapixel camera. The term *megapixel* refers to a collection of one million pixels.

Your camera includes several choices for how many pixels are included in each photo. Some cameras display these options as actual pixel dimensions, referring to the number of pixels making up the length and width of an image as in **Figure 6.4**. If your camera is one of these, you'll see settings like 5026 x 3350, 3489 x 2326, and 2343 x 1562.

If the length and width are multiplied together, the result is the total number of pixels contained within the image. In the example in Figure 6.4, 5026 x 3350 equals roughly 16.8 million pixels (or 16.8 megapixels). The higher the numbers, the more pixels your image will contain.

pixel dimensions: 5026 x 3350

ISO 200
1/3200 sec.
f/2.8
200mm

3350 pixels

5026 pixels

FIGURE 6.4

The term "pixel dimensions" refers to the number of pixels making up the width and height of an image. If multiplied together, the result is the total number of pixels contained within the image. In this example, 5026 x 3350 equals roughly 16.8 million pixels (or 16.8 megapixels).

WHAT'S UP WITH THAT JAGGED-LOOKING STAIRCASE NEXT TO THE SIZE SETTINGS?

In addition to selecting the number of pixels your camera records in each image, you probably have several quality settings to choose from.

As you learned earlier in this chapter, JPG files are compressed before being saved to the memory card. Many cameras give you a choice about how much compression is applied. Highly compressed files ◢L take up less space on a disc but compromise quality to do so. On the other hand, less compressed files ◢L may take up more disc space, but the image quality is higher. When in doubt, keep your pixel count high and your compression setting low for the highest-quality JPG possible.

Other camera models depict image size options as if they were T-shirts. "L" is your camera's largest setting, "M" is a midsize setting, and as you would expect, "S" is the smallest size option. There are also cameras that list image sizes strictly in terms of megapixels. On these models, you'll see options like 12MP, 6MP, and 2MP.

PIXELS AND RESOLUTION

You probably know that having a lot of pixels in an image is generally a good thing, but what you may not fully understand is why.

Most people answer this question with something along the lines of, "The more pixels you have, the higher quality your image will be." Or "The more pixels you have, the sharper the photo will be." While these folks have the right idea, they aren't quite grasping the whole picture. (Wait—was that a pun!?)

The reality is that you could have a high-quality image with only one million pixels and a poor-quality image containing upward of 12 million pixels. What gives?

As it turns out, it's not so much the sheer number of pixels that matter but rather the number of pixels per inch an image has when printed at a certain size. This magical number is referred to as the resolution of an image.

To achieve photographic print quality, a certain resolution (number of pixels per inch) is required. The exact number will vary based on where and how the image is used, the output device creating it, and the material it's printed on, but here are some general guidelines:

- Home/office printing: Resolution of 150 pixels per inch (ppi)

- Professional printing: Resolution of 300 pixels per inch (ppi)

As you can imagine, the larger the print size, the more pixels will be required to achieve the necessary resolution (otherwise the image might look more like a mosaic than a photograph).

In other words, a 16 x 20 image printed at a resolution of 300 ppi would require more pixels than a 4 x 6 image printed at the same resolution.

Get it? This is where your camera's megapixel capabilities count. The more pixels your camera can capture, the larger you can print with adequate resolution. (Keep in mind that the guidelines above are just generalizations, not requirements. In some cases, prints made with lower resolutions can look surprisingly decent, depending on how and where the image is used. For example, a billboard placed far away from viewers does not require the same resolution a print held in your hands would demand.)

RESOLUTION AND PRINT SIZE

Because resolution is a function of pixels per inch, it will change depending on the size of the printed image. For simplicity's sake, let's look at an example of an image measuring 400 x 600 pixels. **Figure 6.5** shows how the resolution would change as the image is printed at various sizes.

- If printed at 2 x 3 inches, the image would have a resolution of 200 ppi.

- If printed at 4 x 6 inches, the image would have a resolution of 100 ppi.

- If printed at 8 x 12 inches, the image would have a resolution of 50 ppi.

Though the images in Figure 6.5 vary in terms of resolution and print size, they're equal in terms of pixel dimensions—each measuring a total of 400 x 600 pixels.

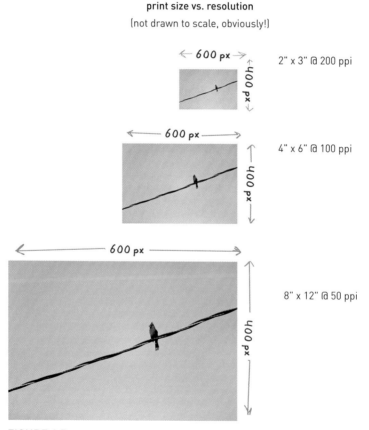

FIGURE 6.5
The print size and resolution of each image may vary, but all three are equal in terms of pixel dimensions, measuring exactly 400 x 600 pixels each. Note that as the print size goes up, the resolution goes down.

As an image's print size increases, its resolution decreases and vice versa. So while the image in Figure 6.5 would be considered low resolution if printed as an 8 x 12, it would have a decently high resolution when printed as a 2 x 3.

Any time you print an image, the pixels will distribute themselves across the entire printable area. The larger the printable area, the further distributed the pixels will have to be. Therefore, if you're making a larger print like a 16 x 20, the pixels will literally have to cover more ground than they would if you printed a 4 x 6. The result is a lower pixel-per-inch distribution (resolution).

DECIPHERING THE NUMBERS

Wondering where the numbers in Figure 6.5 came from? Here's the scoop: Resolution equals pixel dimensions divided by print size. In other words, if an image measuring 600 pixels across is printed six inches wide, it has a resolution of 100 ppi. By the same token, print size equals pixel dimensions divided by resolution. So if the same image is 400 pixels tall and is printed at 100 ppi, the height is four inches. Because all three images in Figure 6.5 are equal in terms of pixel dimensions, you can multiply the print size by the resolution and always get the same results: 400 x 600 pixels.

If you're more of an analogy person, think of it this way: pixels behave like water. They spread out to fill whatever size container they're placed in. Eight ounces of water poured into a small cup (**Figure 6.6**) will have a greater depth (higher resolution) than if the same eight ounces were poured into a larger container like a baking dish (**Figure 6.7**).

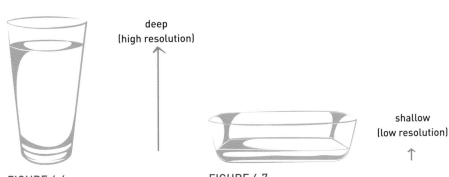

FIGURE 6.6
Eight ounces of water poured into a small glass appears deep.

FIGURE 6.7
The same eight ounces of water poured into a large dish would be shallower.

Get it? Imagine how shallow the water would be if you tried to fill something as large as a *bathtub* with the same eight ounces! Just as water distributes itself in whichever container you pour it into, pixels distribute themselves in whatever size print you're making. Simple stuff, right?

WHAT ABOUT PHOTOS ON THE WEB OR OTHER DEVICES?

Have you ever received a photo via email and, when you looked at it, the image appeared huge on your screen, requiring you to scroll to see it all?

Unlike printed photos, images viewed on-screen aren't displayed in inches. Instead, they're displayed pixel for pixel.

As seen in **Figure 6.8**, if a monitor's display is set to 1280 x 720 pixels, then any image with pixel dimensions exceeding that size would require scrolling. For this reason, images bound for on-screen display need to be resized first. Some online applications like Facebook and Flickr will resize images for you. In other instances, you'll need to do it yourself using the software that came with your camera or another application such as iPhoto, Adobe Photoshop, or Adobe Photoshop Elements.

FIGURE 6.8

HOW BIG IS TOO BIG?

Now that you're getting the hang of this whole resolution deal, you may be wondering how large you can print images from your camera before the number of pixels per inch starts to suffer. The reality is that if your camera is capable of 10–12 megapixels or higher, you really don't need to worry much

about print quality, even at larger sizes (unless you're a chronic cropper—in which case, pay close attention to the next part of this chapter!).

For those of you who like details and numbers, the specifics aren't difficult to calculate. You'd need to find the actual pixel dimensions your camera captures. If you're not sure, you can check your camera's image size settings, use photo software to examine an image you've already shot, or look it up in your user guide.

For example, let's say the images from your 10.5-megapixel camera have dimensions of 2650 x 3975 pixels. To figure out how large you could print at 300 ppi, just divide the length and width by 300 to get an answer of 8" x 13". If you want to print at 150 ppi, you could go as large as 17" x 26"!

Remember, the 300-ppi benchmark mentioned earlier is just to help you put things in perspective. It is not a requirement, merely a suggestion. These days, with most cameras capturing a minimum of 10–12 megapixels, print size is not a major concern.

PIXELS DON'T GROW ON TREES!

While you can always downsize your images (using photo editing software to literally throw away pixels), you can't add pixels that weren't there in the first place. (Because they don't grow on trees, where would the new pixels come from anyway? The pixel fairy?)

Since you can't make up for pixels that weren't captured in the original image, I recommend that you keep your camera's settings on the largest image size possible for the most flexibility later. For example, imagine if you're on vacation somewhere and manage to score a *once-in-a-lifetime* image. I mean, the type of history-in-the-making, life-altering image that could fetch big bucks on a magazine cover. *Lucky you!*

Now, imagine the disappointment you'd feel (not to mention the dwindling pay day) if it turned out you forgot your camera's image size was set so small that the image could never be printed larger than a pack of chewing gum. *Major bummer.*

Save yourself from such a situation by shooting at full size so you can dream big, shoot big, and print big (if you're so inclined).

That said…

BEWARE THE MEGAPIXEL SEDUCTRESS

Manufacturers are always pimping newer cameras with higher and higher mega-pixel capabilities. Before you crack open your wallet and shell out the cash, ask yourself if you *really* need all those extra little squares in your photos. Do you routinely print large, poster-size images? Have you often felt limited by the number of pixels your current camera produces for you? Are you a cropping fanatic? Or are you more of a 4 x 6 person who considers an 8 x 10 to be huge?

There are legitimate reasons why some people truly need a 21- (or even 60!) megapixel camera, but chances are most people don't.

All those extra megapixels tend to come with hidden costs you might not have thought of. You may quickly find yourself needing bigger memory cards, a faster card reader, and a larger hard drive (not to mention a more robust computer processor). Unless you find yourself routinely limited resolution-wise, you're probably okay with the camera (and megapixels) you already have.

DEATH BY CROPPING

Even with the grooviest, most super-schmanciest camera in all the world, there's one thing that can ruin your image and your day: cropping.

It starts out innocently enough. Uncle Joe falling asleep during his niece's wedding vows? Gone! That huge mess under the table as Tommy blows out the candles on his birthday cake? Vanished! Those random strangers in the background of all your must-have tourist photos? No more!

I don't want to induce a panic, so before you break into a cold sweat, let me say this—not *all* forms of cropping are bad. Some crops are mild and may actually be unavoidable. But if used recklessly—as is frequently done—crop-ping has the potential to be one of *the* most destructive things you could possibly do to an otherwise great image.

If you're among the chronic croppers out there who may have gotten a bit too comfortable with the cropping tool—this section is for you.

MILD AND UNAVOIDABLE CROPS

Any time you print an image at a size that's not a multiple of the original size, cropping is unavoidable. For example, **Figure 6.9** shows an image as originally captured in camera. **Figure 6.10** shows the same image as it would appear when printed as a 5 x 7, and **Figure 6.11** shows the image as cropped for an 8 x 10.

ISO 80
1/50 sec.
f/4
6mm (28mm)

FIGURE 6.9
The original, uncropped image.

FIGURE 6.10
The black strips represent the area that would be unavoidably cropped away for a 5 x 7 print.

FIGURE 6.11
The same image, as it would be cropped for an 8 x 10.

This unavoidable cropping is due to a difference in something called "aspect ratio," which is the relationship between the width and height of an image. Because common photo and frame sizes (such as 4 x 6, 5 x 7, 8 x 10, and 11 x 14) are *all different* aspect ratios, they each result in a different crop of the same image. (A 16 x 20, however, would have the same crop as an 8 x 10 or a 4 x 5 because they're all multiples of 4 x 5. Get it?)

CROPPING AT PHOTO LABS

When you order photos at various sizes, the default crop will be centered (as seen in Figures 6.10 and 6.11). Some labs allow you to adjust the crop on either side when placing your order. This may help prevent important parts of your scene from getting trimmed off.

Thankfully, cropping for aspect ratio is generally mild enough that there's no harm done, as long as important parts of the photo don't get trimmed away. It's only when you venture *beyond* the innocent realm of aspect ratio cropping, onto the slippery slope I like to call "extreme cropping," that things get dicey.

EXTREME CROPPING

Like any extreme sport (bungee jumping, cliff diving, or wind surfing), extreme cropping can be dangerous and should be practiced with care. Any time you crop images, you are *literally throwing away pixels*—which you likely paid good money for! And after devoting a section of this chapter to how valuable pixels are, you can see how recklessly *abandoning them* could demolish your chances for high-quality enlargements.

The extent of the damage you do with the crop tool will ultimately depend on how many pixels you started with, how dramatically you cropped, and how large you were hoping to output the image afterward. It's possible that even though you originally had enough pixels for a high-quality enlargement (poster size, anyone?), after an extreme cropping massacre, you may be lucky to get a high-quality *wallet-size* print, let alone a 4 x 6.

What constitutes an extreme crop? Generally, it's any crop where the size of the area being cut away is larger than the size of what is left behind. The photo in **Figure 6.12**, for example, is a prime target for extreme cropping. Captured from a considerable distance, the subject appears small and the scene is stolen by a smorgasbord of visual clutter.

ISO 250
1/80 sec.
f/3.5
13mm (60mm)

FIGURE 6.12
With only a mild crop for aspect ratio, this 10-megapixel image has more than enough pixels to be printed as an 8 x 10 with an overflowing resolution of 342 ppi.

If you were to overlook the clutter and print the 10-megapixel image as an 8 x 10 (with mild cropping for aspect ratio only), the resulting image would weigh in with a whopping 342 ppi—well above the 300 ppi standard for high-quality prints.

Of course, cropping for aspect ratio isn't quite as exciting as extreme cropping. The results aren't nearly as dramatic. There's no adrenaline rush, no butterflies in your stomach, or sweat beads on your brow—and it certainly wouldn't get rid of all that clutter! And it's precisely because of all the unwanted clutter that people roll up their sleeves, sharpen their crop tools (figuratively speaking), and start hacking away. Unfortunately, the improved image may come at a high cost.

Figure 6.13 illustrates the effect cropping has on image size and, subsequently, on output options. Cropping for aspect ratio only, the first example leaves behind more than enough pixels for a high-resolution 8 x 10. Conversely, both of the remaining examples are *extreme crops* and would severely limit your enlargement options. An 8 x 10 of the middle crop would have only 140 pixels per inch, while an 8 x 10 of the most extreme crop would have an even more dismal resolution of 75 pixels per inch. (As you learned earlier in this chapter, that's a long way from the 150 to 300 ppi required for a decent print!)

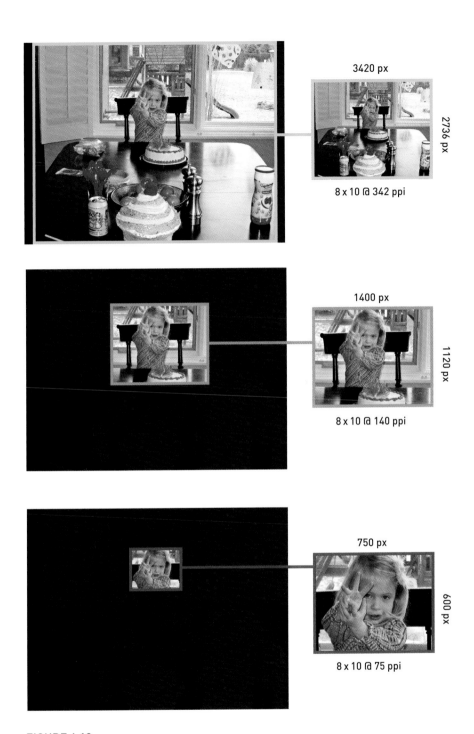

3420 px

2736 px

8 x 10 @ 342 ppi

1400 px

1120 px

8 x 10 @ 140 ppi

750 px

600 px

8 x 10 @ 75 ppi

FIGURE 6.13
Even a fancy 10-megapixel image can be brought to its mercy by extreme use of the crop tool. Notice how the pixel dimensions and enlargement potential dwindle as the crops become more extreme.

Believe it or not, cropping your photos is somewhat similar to baking cookies, only without the sugar rush. (Seriously!)

Imagine mixing up a big ol' batch of homemade cookie dough. After rolling it out into a nice flat sheet, imagine placing a single cookie-cutter in the center— then peeling off and throwing away all the dough *outside* the cookie-cutter.

What would happen if you took the remaining piece of dough (the piece you just cut out with the cookie cutter), and tried to enlarge it by stretching it out to fill an entire cookie sheet? That'd be crazy, right? I'm no culinary genius, but I can tell you with some degree of certainty that it won't work (err—not that I've ever tried it).

It's the same with photos. Simple, right?

Rather than continuing to shoot photos peppered with clutter and learning to live with the cropping consequences—why not figure out how to have your cake and eat it too?

GETTING CLOSER AND CROPPING LESS

With a little practice, you can lessen your dependency on the crop tool for clutter removal and start enjoying better-looking images complete with the megapixels you deserve (and paid for). The trick is to get *closer.*

Much closer.

It's the number one way to *dramatic*ally improve your images. And—it's free.

By default, most people snap photos from *waaay* too far away. Don't believe me? The next time you're on vacation, ask a stranger to take your photo and watch what they do next. Chances are they'll turn and walk fairly far away, leaving you with something like the photo in **Figure 6.14**.

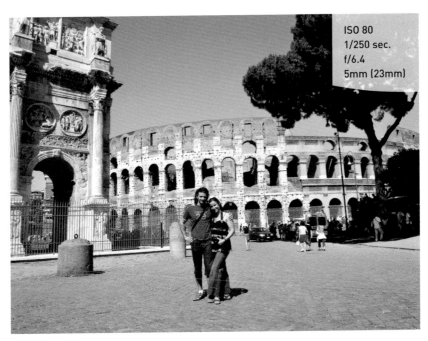

ISO 80
1/250 sec.
f/6.4
5mm (23mm)

FIGURE 6.14
Our unknown shutterbug managed to fit nearly the entire Colosseum in the background behind us. On the flip side, my eyes might be closed, but it's shot from so far away, I can't tell!

The kind (and insistent) stranger who took our photo walked far enough away to not only fit almost the *entire* Colosseum in the background, but also a few motor vehicles, an additional example of Roman architecture, and a collection of random strangers.

While many of the strangers who offer to take your photo may not have read this book (of course, there *is* the possibility that it will become a runaway best seller, reaching camera-loving strangers around the globe—spread the word!), you have read it. And now it's your responsibility to do your part to rid your photos of unnecessary clutter. This could easily be a turning point for you and your images!

Improving your photography (while simultaneously preventing a cropping massacre) is as simple as becoming aware of and making conscious choices about where you position yourself relative to your subject. To see what I mean, take a look at **Figure 6.15**. Because the photo was taken from the far end of the table, it includes a fair amount of wasted space and extra items in the foreground (soda can, napkins, etc.), all of which are competing for the viewer's attention, taking away from the *subject.*

ISO 500
1/80 sec.
f/3.5
13mm (60mm)

FIGURE 6.15
Taken from the far end of the table, this image includes a lot of unnecessary clutter, becoming a prime candidate for extreme cropping.

Contrast Figure 6.15 with the photo in **Figure 6.16**, captured from a much closer position. What a difference! There's no magic, special equipment, or luck involved. All it takes is self-awareness and the conscious decision (choice) to *get closer.*

ISO 800
1/80 sec.
f/4
15mm (60mm)

FIGURE 6.16
Captured from a closer position, the image becomes much stronger and more compelling.

So before you snap your next photo, as you peer through your viewfinder (or at the back of your LCD screen), ask yourself this question: If you capture the image from your current position, will you feel compelled to crop it later? If the answer is yes, get those feet moving and *get closer!*

ZOOMING WITH YOUR FEET!

Obviously, you can't *always* get closer. There are sometimes fences, barricades, other people in your way, or various rules you just can't bend. A good zoom lens is nice to have, but in general, you'd be surprised how much you can get away with by just moving your own two feet.

Instead of sloppy shooting followed by extreme cropping, practice making yourself aware of your position relative to your subject (as well as the other items in the scene), and adjust as needed. Then proceed to shoot the photo the way you would otherwise want to crop it later.

It can't be said enough—this simple practice is *the* easiest way to improve your photos, not only slightly, but *dramatically*. Plus, you might burn a calorie or two, and who doesn't love that?

Chapter 6 Assignments

RAW vs. JPG

If your camera has the ability to capture images in the RAW format, try this exercise. Set up a still-life shot—perhaps some fruit or flowers set up next to nice window light—and take two images, one as RAW and one as a JPG. Open these images in your favorite software and see how much more flexibility you have when adjusting the RAW file's exposure, white balance, or color. JPG files may be a perfect fit for you, but it's still good to know the capabilities of RAW.

How Large Can You Print?

Determine your camera's megapixel count and figure out how large a print you could make at a resolution of 300 ppi. You might be surprised to find out that your camera is more than capable of creating a very large print! (Now you just have to figure out where it will go: over the couch or above the fireplace?)

Get Closer

Next time you're taking a shot at a family function or on vacation, ask yourself, "Could I get closer?" If you can, go for it! Getting closer can fill the frame with your subject and eliminate clutter (which, of course, you'll want to crop out later). Get closer and get the shot!

Share your results with the book's Flickr group!

Join the group here: flickr.com/groups/gettingstartedfromsnapshotstogreatshots

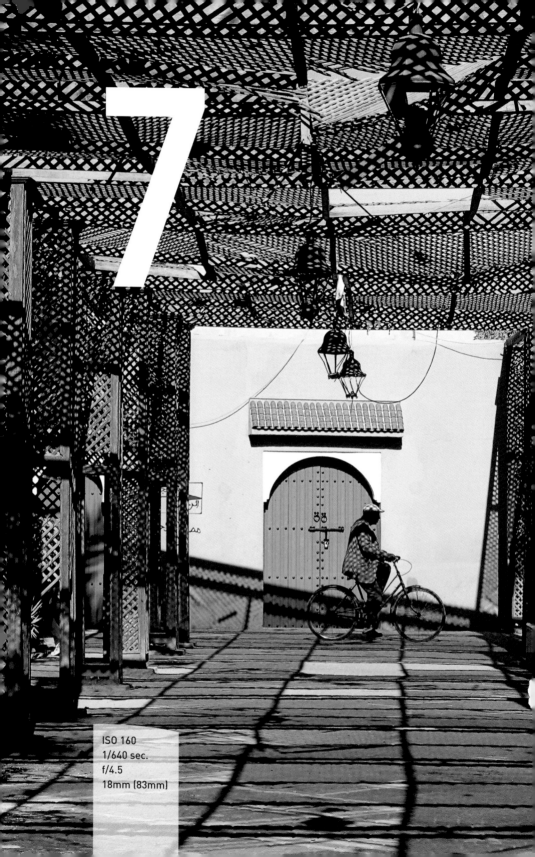

7

ISO 160
1/640 sec.
f/4.5
18mm (83mm)

From Zero to Hero

BETTER PHOTOS ARE YOURS FOR THE TAKING!

Great photos don't just happen. They're born when someone (like you!) steps up and *makes* them happen. While you may get lucky with a great shot every now and then, the only way to *consistently* get great photos is to play an active role in making them what you want them to be. (You've made it this far—there's no sense in turning back now!)

Beyond choosing camera settings (shooting modes, white balance, and so on), you're ready to take your images a step *further.* By becoming aware of your surroundings, learning to see light and background, and making active choices about composition, your photos will improve by leaps and bounds!

PORING OVER THE PICTURE

A solid understanding of composition and an awareness of light means you can make great images with any camera—even your phone. While waiting for a train at DC's Farragut West station, I noticed the way the bright back lighting produced silhouettes of the people who passed in front of it. Without my dSLR or my handy dandy point-and-shoot, I reached for my phone because in the end, you have to use what you've got!

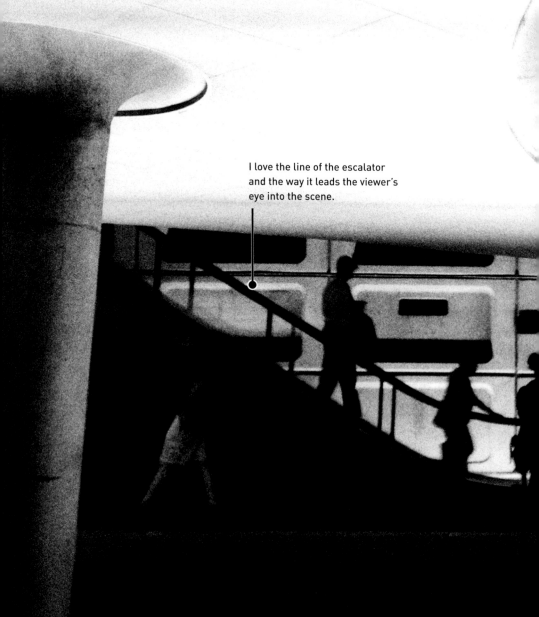

I love the line of the escalator and the way it leads the viewer's eye into the scene.

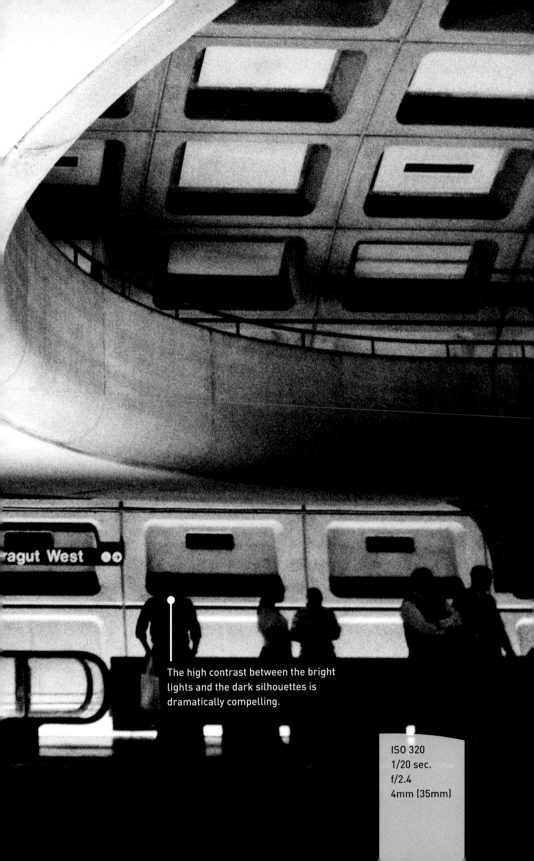

agut West

The high contrast between the bright
lights and the dark silhouettes is
dramatically compelling.

ISO 320
1/20 sec.
f/2.4
4mm (35mm)

SNAPSHOTS VS. PHOTOGRAPHS

Have you ever thought about the difference between a snapshot and a photograph (a great shot!)? How would *you* explain it? When you boil it down, the only real difference is *presence of mind*.

The term "snapshot" generally refers to an image that was captured on a whim without a great deal of thought, attention to detail, or regard for composition—something along the lines of "Ready, aim, fire!" For a lot of people, it's the only way they've ever approached photography (after all, the term "point and shoot" didn't come out of nowhere).

"Photographs," on the other hand, are made with more thought and consideration. Whether captured on a compact point-and-shoot or a fancy schmancy dSLR—a photograph is a carefully made *choice,* captured with intention and executed with astute awareness. As the expression goes, "Snapshots are taken, photographs are *made.*"

Making the leap from shooting snapshots to capturing photographs isn't rocket science, but it will require active participation and a new thinking pattern.

READY, SET, STOP!

If you've been a snapshot shooter all your life, learning to stop and evaluate the scene *before* you shoot will take some getting used to. While your *old* thinking pattern may have been along the lines of see scene, reach for camera, take picture—your *new* thinking pattern is all about awareness, requiring that you learn to see (and evaluate) what you're looking at in a whole new way.

The first step is an easy one. Just—stop. Step back and pause for a moment (or however long it takes) to make yourself aware of two very important aspects of the scene in front of you: the light and the background.

It's funny to think that most of us spend a lifetime looking at—but never really learning to *see*—light and the way it shapes the world around us. It can vary drastically from one environment to the next and is capable of changing dramatically from hour to hour, or even *minute to minute* as clouds move across the sky.

You can practice looking at and learning to see light by exploring some of its basic attributes: quality, color, and direction.

QUALITY OF LIGHT

Not all light is created equal! Light can be soft, or it can be hard. How can you tell the difference?

Examine the shadows. Captured on a bright sunny day, the hard light in **Figure 7.1** produces shadows that are equally hard and well defined.

ISO 100
1/3200 sec.
f/2.8
27mm

FIGURE 7.1
Clear, sunny days produce hard light with equally hard shadows.

Soft light—found either in the open shade, or almost anywhere on a cloudy/overcast day—produces less dramatic and softer shadows, as seen in **Figure 7.2**.

ISO 100
1/2000 sec.
f/1.8
50mm

FIGURE 7.2
Captured in the open shade of a sunny day, the soft light in this scene produces soft shadows.

COLOR OF LIGHT (SOURCE)

Being aware of the source of light in a scene helps you better recognize and anticipate its color temperature (see Chapter 3 for a refresher on white balance and color temperature) and the overall mood it contributes to the scene.

If you're outdoors during the day, your main light source is the sun. If you're inside, it's likely lit from flourescent bulbs, tungsten lamps, or possibly a mix that might also include daylight pouring in from a large window.

Look around and ask yourself if the surrounding light has a cooler color like in the morning just before the sun peeks above the horizon—or a warmer glow, like the last hour before sunset, as seen in **Figure 7.3**.

ISO 200
1/800 sec.
f/2.8
23mm

FIGURE 7.3
As the sun was setting off the Oregon coast, the golden color added a warmth to the image that would be noticably missing if the scene was photographed at noon.

How might the color of the light in your scene affect the image you're about to make? How would the color of the light change if you captured the photo at a different time of day?

DIRECTION OF LIGHT

Light can come from anywhere, illuminating your subjects from above, from the side, behind, or even from below (see **Figure 7.4** for examples).

FIGURE 7.4

Clockwise from top left: Lit with sun from above; lit from a window on the left side of the camera; lit with early evening sun from the left, accentuating the size and shape of the sand dune with dramatic shadows on the right; lit from below using only the light from the campfire; backlit with the sun behind the subjects, resulting in a silhouette portrait.

Before you pick up your camera to shoot, look at the scene in front of you and ask yourself which direction the light is coming from. How does it relate to the direction your subjects are facing? Is the light hitting your subjects in a way that makes them squint? Is it casting funny shadows on their face, as in **Figure 7.5**?

While you can't move the sun, you *can* change its position relative to yours. In **Figure 7.6**, I simply moved about three steps in a clockwise direction and asked Emir to turn my direction, thereby eliminating the shadow that previously cut across his face.

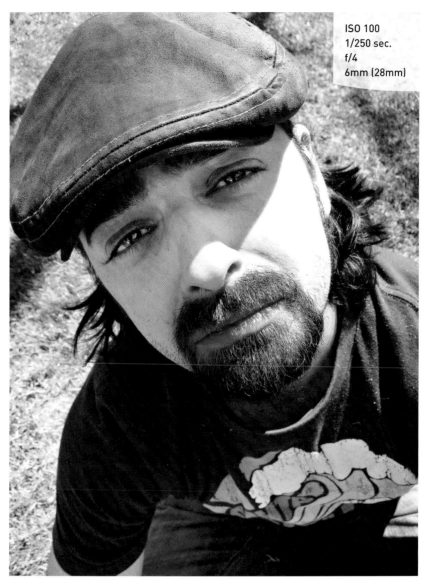

ISO 100
1/250 sec.
f/4
6mm (28mm)

FIGURE 7.5
Emir frowns at me for letting the sun cut across his face, leaving part in shadow, part in highlight.

ISO 100
1/160 sec.
f/4
6mm (28mm)

FIGURE 7.6
To solve the lighting issue on his face, I simply moved three steps clockwise (away from the sun), and as Emir turned to face my new location, his face became more evenly lit. Piece o' cake!

A CHECK ON THE BACKGROUND

Once you learn to see light, the next step is to turn your attention to the background to see what's *behind* your subjects.

Are things such as telephone poles, the neighbor's car, or other people in the way? What about beams and other objects that may appear as though they're coming out of your subject's head? What can you do about it? Could some items be moved? Is it possible to reposition your subject (or yourself) so the eyesores are no longer visible?

For example, if the snapshot in **Figure 7.7** had been captured from a slightly different angle, the cars and street signage might have been blocked from view. How could you have positioned yourself (or the subject) to achieve a less cluttered background?

ISO 80
1/400 sec.
f/2.8
6mm (28mm)

FIGURE 7.7
How might you compose this scene differently for an
uncluttered background?

While you're looking out for the *background,* be sure to also keep an eye on how the foreground interacts with your subject. In **Figure 7.8**, it looks like the green leafy top of the strawberry could double as a silly little moustache!

ISO 80
1/200 sec.
f/2.8
6mm (28mm)

FIGURE 7.8
"I'll have a strawberry daiquiri with a side of green moustache, please!" Unfortunate positioning of the strawberry, relative to my face, makes the leafy green top look like a silly moustache.

GET OFF THE BENCH!

Learning to see light and become aware of the background is a huge step—but it's useless if you don't follow it up with action! This is your ticket to *get off the bench* and become an *active participant* in getting great photos.

After surveying the scene and weighing your options, you may discover that the light is better somewhere else, or that shooting three more feet to the left will enable you to keep the dumpster from showing up in the background. If that's the case, don't just stand there—do something about it!

Strategically choosing a location, asking your subjects to turn and face a different direction, or moving yourself across the room to capture the scene from another perspective comes with the territory of being a photographer (rather than a snapshot shooter).

For example, the images in **Figure**s **7.9** and **7.10** were captured as part of a series for a children's alphabet book I created. Shot exclusively on location in the subjects' own home (making use of whatever toys, props, and backgrounds were available), I asked the kids to stand in front of a plain, well-lit, and brightly colored wall instead of shooting in the middle of the kitchen where we found the apples. The bright yellow looked great next to the apples and added to the overall appeal of not only these images, but of the book as a whole.

ISO 1000
1/100 sec.
f/1.8
50mm

FIGURE 7.9
Shot entirely on location at the subjects' home, I made use of whatever toys, props, and backgrounds were available—in this case, positioning the subject in front of a plain, well-lit, brightly colored wall that looked great with the apples she was holding.

ISO 1000
1/320 sec.
f/1.8
50mm

FIGURE 7.10

If you look carefully and think outside the box, you will likely discover some fantastic backdrops right in your own home. Walls, doors, curtains, and even furniture can make great backgrounds. You never know until you try!

Keep in mind that exerting some influence over the scene doesn't mean that you can't shoot the candid images you might be looking for, but it *does* mean you'll have a much better chance of getting what you want—and who doesn't like that?

For example, if you're photographing the kids running through sprinklers in the front yard, but you can't bear the sight of your unfinished porch or goofy looking mailbox in every image—why not just move the sprinkler (and the kids) to the backyard?

If you want to capture your children at play in the living room, but the light (or severe lack of it) is bumming you out, a simple, "Hey kids! Can you show me how you play with the toys *over here* by the window?" will usually suffice.

While there are certainly situations in which it's not practical (or even possible) to move your subject, being able to see the light, being aware of the background, and adjusting accordingly empowers you with the ability to make the most of any scene.

PRACTICE IDEAS

Putting together a collection of images for something like an alphabet book is a great way to practice your developing photo skills. And when you're done, you'll have a timeless treasure for your family!

If you are hungry for a little inspiration or just want to take a closer look at the book I made, visit kabloomstudios.com/blog/alphabet-book.

COMPOSITION—IT'S NOT JUST FOR MUSICIANS AND ENGLISH MAJORS

Once you've found the light and background that suit your fancy, how exactly will you put it all together? Where will you position yourself? How close will you get? What will you focus on or draw attention to?

The way you choose to frame an image is called "composition." And while snapshot shooters aim and fire, photographers compose. It has a lovely ring to it, doesn't it?

Every time you raise the camera up to capture an image, you are making a choice. And in addition to choosing all the things we've already talked about—such as exposure settings, white balance, and focal length—with every click of the shutter, you are also choosing the angle you shoot from, the part of the scene you want to draw attention to, the exact moment you want to capture, and, ultimately, the story your image tells.

The expression "A picture is worth a thousand words" comes from the idea that images tell stories, usually much better than we do. So be sure to craft your pictures carefully. Changing any of the variables will change the image and, thus, the story it tells. That's the power of composition.

There are lots of ways to strengthen the stories your images tell. The more you practice, the better your images—and their stories—will become.

BE EXCLUSIVE

The story you choose to tell with your photos can vary dramatically depending on what you choose to include in the image and—perhaps even more important—what you choose to exclude.

For example, what do you see when you look at **Figure 7.11**? A young boy, seeking thrill and adventure? Perhaps. But what you *don't* see is the parking lot in the background (filled with fire trucks and crawling with people—apparently some sort of fair was taking place). Though it may look like Ryan is risking his life leaping between two seemingly tall cliffs, in reality he's about three feet off the ground in a grassy city park.

Was this an accident? Not a chance.

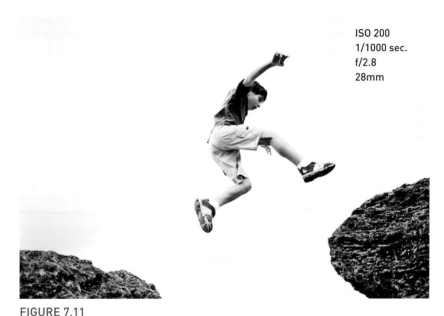

ISO 200
1/1000 sec.
f/2.8
28mm

FIGURE 7.11
Shot with a wide lens (28mm) from a low angle (purposely excluding the background), it appears as though Ryan is risking life and limb on a daring leap of faith—when in actuality, he's three feet off the ground in a city park.

If I had shot without pausing to think first, I might have taken the image while standing. And if I didn't feel like moving, I'd probably have shot it from a pretty far distance—revealing the crowded parking lot in the background and the grassy turf only three feet below. But because I paused before firing, I had time to make some choices.

I *chose* to lay on my back at the bottom of the rocks and shoot at an upward angle, creating the illusion that Ryan was a cliff-jumping daredevil by excluding the parking lot and ground (only three feet below) from view.

I *chose* to shoot wide enough to show both the left and the right rocks, but not *too wide* that you can see the far edge of either rock, revealing their true size (which was actually quite small in comparison to how they look in the photo).

Suddenly, because of these choices, the image takes on a new meaning. Instead of just another snapshot at the park, this image tells a story about Ryan and his youthful, adventurous spirit.

EXPLORE A NEW PERSPECTIVE

Just as many people have a tendency to take photos from much too far away, most also have a tendency to shoot everything from eye level while in a standing position. The next time you find yourself with a camera in your hands, take a moment to explore some alternatives.

Shooting down from above can sometimes reveal interesting patterns and shapes that may otherwise be missed. Whether you climb a ladder or ledge, or just stand on your tiptoes, shooting from above can transform almost any scene (**Figures 7.12** and **7.13**).

ISO 800
1/25 sec.
f/2
6mm (28mm)

FIGURE 7.12
Shooting down from the second-story balcony of a restaurant reveals shapes and patterns not visible from the ground level.

ISO 200
1/1600 sec.
f/2.8
50mm

FIGURE 7.13
If you think that photographing kids at the park is a passive endeavor, think again! The more you're willing to get involved and play along, the more interesting your photos will become. This image was captured from on top of the playground equipment, shooting down through the climbing rings.

On the other hand, getting down low (possibly even beneath your subjects) and shooting upward, as in **Figure 7.14**, is a great way to not only find an interesting view, but also to hide any unwanted background!

ISO 200
1/800 sec.
f/2.8
33mm

FIGURE 7.14
This photo of Lily and her dad, Brian, has an extra touch of fun and whimsy thanks to the unique angle it was captured from.

Exploring new perspectives usually involves more than standing in one spot and simply leaning in either direction (lame!). Don't be afraid to really roll up your sleeves and dig in, even if it means looking ridiculous temporarily. Great images last forever; the embarrassment you endure while contorting yourself into whatever it takes to get the shot you want is only temporary.

Many photos can be greatly improved by simply shooting from the subject's eye level. **Figure 7.15** was captured in the tragically common default shooting position of standing while aiming the camera in whichever direction the subject happens to be. **Figure 7.16**, on the other hand, was captured while lying on the floor at the subject's eye level. Which image do you find more compelling?

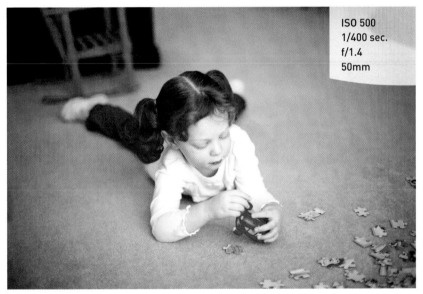

ISO 500
1/400 sec.
f/1.4
50mm

FIGURE 7.15
Captured from a typical standing position while shooting downward, this image lacks any real connection to the subject.

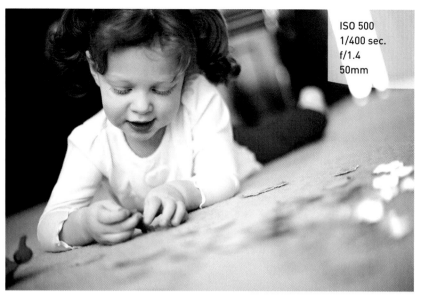

ISO 500
1/400 sec.
f/1.4
50mm

FIGURE 7.16
Getting down on the subject's level makes this a far more compelling composition.

GET CLOSE AND BE DETAILED

As you read in the previous chapter, one of the best ways you can improve your photos is to simply *get closer.*

Whether you're shooting a portrait of a loved one, photographing the trip of a lifetime, or capturing a lazy afternoon with the kids, your images can be dramatically improved by reducing the distance between you and your subjects.

Once you get comfortable at shorter distances, scour the scene for *details* that can make great images and help tell your story. If you're looking to make some special portraits of grandma, include a close-up of her hands and the character they reveal.

When you travel, make it a point to capture the textures and colors that surround you (**Figure 7.17**). Simple architectural details, close-ups of street signs, trinkets from the local market, or maps of your whereabouts will tell the story of your trip in a new way (while simultaneously building a frame-worthy collection of great images for your wall when you get back!).

FIGURE 7.17
Capturing images of colors, shapes, and textures while traveling makes for great souvenirs.

When photographing your kids, don't leave out the details of messy faces, skinned knees, muddy feet (**Figure 7.18**), and missing baby teeth. Those are real memories, and they usually have great stories to go with them.

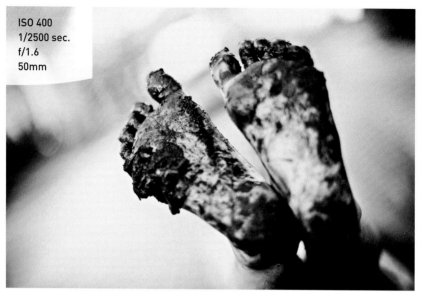

ISO 400
1/2500 sec.
f/1.6
50mm

FIGURE 7.18
The messy details of life can make for some of the best images—don't overlook them!

SET THE SCENE

In addition to some great close-ups, don't overlook the potential to be found in wider shots such as **Figure 7.19**. Powerful in their own way, wide shots set the scene by helping viewers fully appreciate where the story is taking place.

Want to take your storytelling skills to the next level? Combine wide, scene-setting images with a collection of details and close-ups and the story you tell will have much more depth.

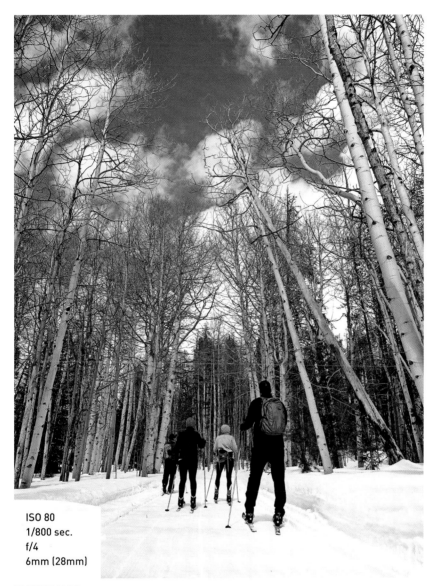

ISO 80
1/800 sec.
f/4
6mm (28mm)

FIGURE 7.19
A story about skiing the backcountry in Colorado wouldn't be the same without a view of
the aspen trees.

HOLD THE CHEESE, PLEASE!

It's common to tell your subjects, "Say cheese!" when trying to photograph them. Unfortunately, it's often counterproductive, boring and generally—pretty *cheesy*. Learning to hold back can be a tough habit to break, but with practice, you can train yourself to banish the "cheese" from your photos for good.

Instead of asking your subjects to look at the camera with phony grins, *engage them.* Distract them with jokes, keep them focused on a task or activity, or redirect their attention to something else. Or, if you're photographing children, ask them to arm wrestle, tickle each other, or whisper something silly to the person next to them—anything you can think of to elicit a genuine expression.

Even if that genuine expression isn't the huge grin you may be hoping for, don't panic. Ask yourself if you'd really rather end up with a picture of a forced, phony smile instead of something genuine that accurately depicts your subject and how he or she feels in that given moment.

In **Figure 7.20**, Evan wasn't interested in his mother's plea for cooperation with the camera. Although the expression on his face is far from anything resembling the smile she would've liked, his look says infinitely more about the dynamic person he is and the breadth of emotion he's capable of than a cheesy smile ever could!

ISO 200
1/125 sec.
f/9.5
80mm

FIGURE 7.20
Genuine emotion trumps a coerced expression any day, even if it's not the smile you were hoping for.

MAKE EYE CONTACT OPTIONAL

Once you learn to take a pass on the cheese, you can take your photos to a whole new level by acknowledging that there's no law—anywhere—that requires your subjects to always be looking at the camera. In fact, you may discover you really love the images captured when your subject forgot you were even there!

When subjects aren't forced to acknowledge the camera, they're free to continue living in the moment—and you're free to document it, capturing a more accurate glimpse of the real story. It might be the temper tantrum your two-year-old throws in protest of bath time, the "new haircut" you catch big sister giving to little sister, or the way the kids always seem to end up wearing their lunch.

Figure 7.21 is one of my all-time favorites images—and not a single kid is looking at the camera. Big sister Ellie leads by example while Evan wrestles with some runaway spaghetti sauce and Eva holds her own as the youngest, trying to get a bite before the plate is cleared.

ISO 640
1/80 sec.
f/2.5
50mm

FIGURE 7.21
Over time, you may discover that some of your favorite images come from moments when you let the scene unfold naturally, as if you weren't even there—instead of asking your subjects to stop what they're doing and look at the camera.

It's a great example of what's possible when you leave your subjects alone and just let them *be*. Instead of drawing attention to yourself and demanding that everyone stop what they're doing and look at the camera, try letting the scene unfold, *as if you weren't even there.*

TUNE UP YOUR TIMING

Similar to the way your favorite actor's sense of timing can propel him or her toward a legendary comedy career, developing a good sense of *photographic timing* can take your images to new heights.

More than just the successful synchronization of your shutter with the basketball player in midair, or the soccer ball as it reaches the peak of its arc on its way to the goal, photographic timing is about learning to recognize (and grab) a key moment when you see it.

One of the best ways to sharpen your sense of timing is to work on your patience while learning to *anticipate*. Rather than rushing to catch up all the time, get ahead of great photo moments by guessing when and where they might present themselves so you can be ready when the time is right. Over time, you'll get better and better at spotting potentially great photo moments before they happen and capturing them when they do.

A single moment has the ability to communicate a sense of connection and playfulness (**Figure 7.22**) or convey the sheer power of emotion (**Figure 7.23**). As the moments stream past you, which ones will you reach out and grab?

ISO 200
1/640 sec.
f/2.8
50mm

FIGURE 7.22
The expression on Susan's face makes this photo moment one of my favorites. Being able to recognize and respond to whichever moments speak to you will take your images to a higher level.

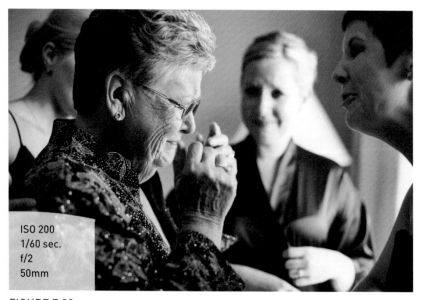

ISO 200
1/60 sec.
f/2
50mm

FIGURE 7.23
Weddings are filled with countless photo-worthy moments. If you're prepared and keep a watchful eye, you'll have a better chance of catching them. In this image, Rosemarie is about to help her youngest daughter into her wedding dress when she's overcome with emotion.

DON'T DEFAULT TO CENTER

As you become mindful of what you're shooting and how you're shooting it, you may discover a stubborn tendency to put your subjects in the center of the frame all the time. While there's nothing intrinsically wrong with centering your subject in the middle of the frame, make sure you're *choosing* to do it with purpose and intent—and not by default.

Centering your subject in the frame can often leave you with compositions that feel trapped, lifeless, or worse—just plain boring. (Gasp!) Who wants that?

Instead, a well-known principle called the "rule of thirds" can help breathe new life into your photos. The principle calls for dividing your frame into thirds both horizontally and vertically (as seen in **Figure 7.24**), and positioning your subject at one of the points where the lines intersect rather than in the center. Doing so makes for more interesting, purposeful, and dynamic compositions.

FIGURE 7.24
The rule of thirds calls for dividing the frame horizontally and vertically, and positioning subjects near one of four "points of interest" where the lines intersect.

THE RULE OF THIRDS AND YOUR CAMERA

Some cameras have a "rule of thirds" grid built into the viewfinder or display options on the LCD screen. If you don't see it on your screen by default, there's usually a button or menu option you can access to turn this feature on. Check your camera guide for details.

The image in **Figure 7.25** was composed with the rule of thirds in mind. Because the gentlemen's gaze leads viewers' eyes to the left, the men are positioned along the right third of the frame, giving viewers' eyes room to follow their gaze without falling out of the frame.

The rule of thirds can be applied to both horizontal and vertical shots—as in **Figure 7.26**.

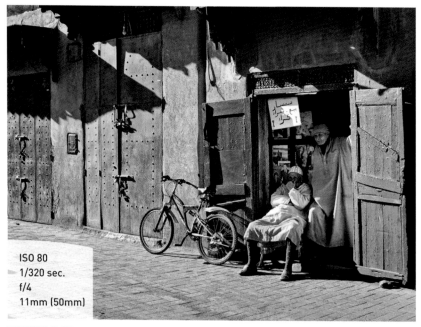

ISO 80
1/320 sec.
f/4
11mm (50mm)

FIGURE 7.25
Using the rule of thirds as a guide, the subjects were positioned along the right third of the frame, giving the viewer room to follow the men's gaze to the left.

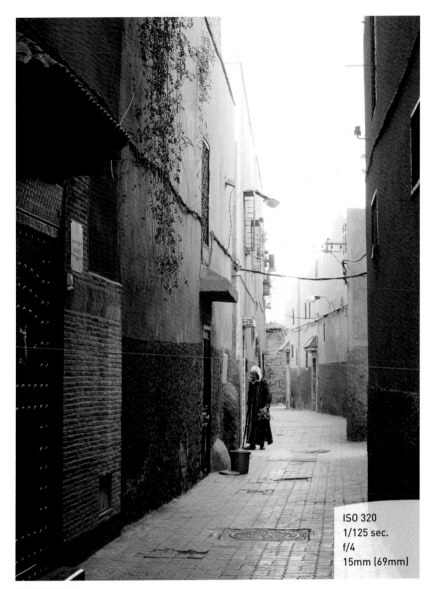

ISO 320
1/125 sec.
f/4
15mm (69mm)

FIGURE 7.26
The convergence of the walls with the road was positioned in the bottom right third of the frame to lead viewers' eyes into the image. The woman in the scene provides scale and reference.

Figures 7.27–7.29 show how the rule of thirds was employed in a variety of images. Once you're aware of the way you're choosing to build your compositions, using the rule of thirds becomes second nature. Of course, rules are made to be broken—but they're usually broken best *after* you fully understand them.

FIGURE 7.27
The rule of thirds can be helpful when positioning the horizon in a landscape image.

FIGURE 7.28
In this cityscape scene, the horizon is a natural fit along the bottom third of the frame.

FIGURE 7.29
Of course, you can also apply the same principle to vertical compositions.

Chapter 7 Assignments

Taking your photos from zero to hero isn't rocket science—all it takes is simple awareness and presence of mind.

A Clean Background

When you're in a situation where the image seems clutter, take a look around. Make yourself aware of the background, then position yourself (or your subjects) accordingly by getting off the bench, speaking up, and taking action to shape the scene however it works best.

Hold the Cheese

Take your favorite portrait subject out for the afternoon, and take your photos to a whole new level by forcing yourself to "hold the cheese," not demanding eye contact in every shot, and working on your timing. Talk to your subject, and see if you can elicit a look from them that goes beyond the cheesy grin.

Rule of Thirds

Take a day (or a week!) and give yourself the order to *not* place your subject in the middle of the frame. Explore the rule of thirds and the ways you can use it to make your compositions more interesting and dynamic.

Share your results with the book's Flickr group!

Join the group here: flickr.com/groups/gettingstartedfromsnapshotstogreatshots

PORING OVER THE PICTURE

Walking the streets of downtown Seattle, I came across this scene and was struck by how it framed the Space Needle so perfectly. Isn't it amazing how easy it is to find compelling imagery if you simply pay attention?

ISO 50
1/1500 sec.
f/2.4
4mm (35mm)

Life After the Click

DOWNLOADING, BACKING UP, AND SHARING YOUR IMAGES

Contrary to what you might think, getting a great shot is actually not the end of the story. There's more fun to be had! Now it's time to start the process of getting that image off your memory card, securely backed up, and ready to share with the world. (After all, sharing your images *is* the whole point of all this, right?!)

8

ISO 100
1/4000 sec.
f/2.8
27mm

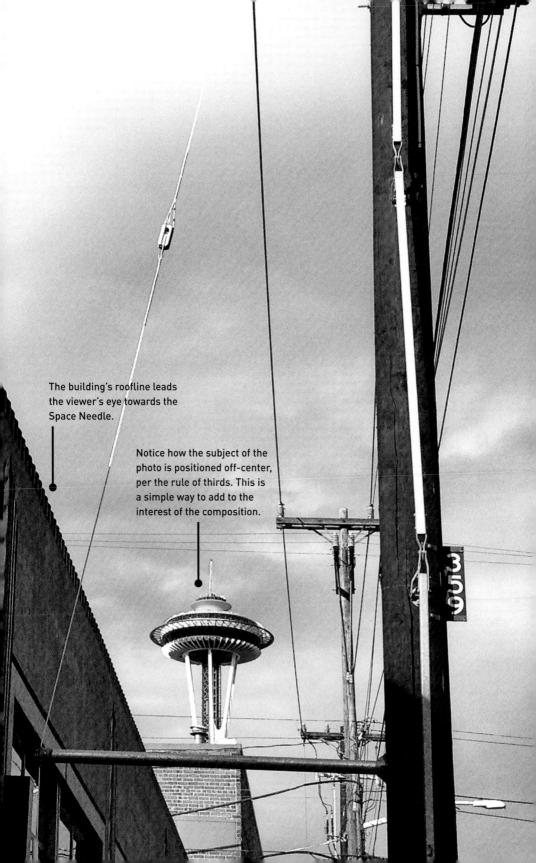

The building's roofline leads the viewer's eye towards the Space Needle.

Notice how the subject of the photo is positioned off-center, per the rule of thirds. This is a simple way to add to the interest of the composition.

THE 411 ON DOWNLOADING

Now that you've captured some great images, it's time to liberate them from the confines of your memory card so you can start enjoying them! Generally speaking, this means moving your images to a computer.

Whether you're a self-proclaimed computer geek or more of a technophobe, you'll be happy to know there are several options to choose from (including one for the diehards who may prefer to leave the computer totally out of it).

MEMORY CARDS

The images your camera captures are stored on a memory card (**Figure 8.1**). Memory cards are available in several different formats, the most common of which are secure digital (SD) and compact flash (CF). Some camera models may use less common memory card formats such as Memory Sticks or xD cards.

The number on the card represents how much storage capacity it has—for example, 12 gigabytes versus 8 gigabytes. The larger the capacity, the more data the card can store, meaning the more photos you can save on them.

While it may be temping to purchase memory cards in the most ginormous capacity you can find, smaller capacity cards are helpful in that they force you to *actually* download the images now and then (instead of letting them pile up for six months). This reduces the number of images you would lose if your memory card becomes corrupt (or your camera is lost or stolen).

FIGURE 8.1

12-gigabyte
CF card

8-gigabyte
SD card

KICKIN' IT OLD SCHOOL

Although digital photography goes hand-in-hand with computers for most people, some folks out there *really dig* the way photo processing has been handled for years and don't want to let computers come between them and the images they love. Back in the day, getting your photos processed meant stopping by your local shop, dropping off your film, then coming back a day or so later to pick up your prints (and corresponding negatives). There were no computers, no hard drives, and no cables.

If you prefer to keep it that way, it's still entirely possible. Just grab your camera and head to your favorite photo processing shop. As long as they have a photo department with a kiosk, you'll be all set. Take out your camera's memory card, insert it into the kiosk, and follow the prompts on the screen to order the prints you want. Depending on the options you choose, your prints may be ready in under an hour!

If you want to keep the original files (the digital equivalent of your negatives), most stores will burn the files to disc for a small additional fee—no computer required. (Later in this chapter we'll talk more about the longevity of CDs and DVDs for long-term archival purposes.)

CONNECTING WITH YOUR COMPUTER

For most people, the next step after capturing a collection of images is to get them transferred onto their hard drive. To do so, you'll need a way to connect your memory card with your computer. As luck would have it, there's more than one way to do so, and no matter which method you choose, the process is easy.

LABEL YOUR USB CABLES

Even though the USB end of the cable is universal, the part that connects with the camera varies from model to model. If you have more than one camera (and therefore more than one cable), it is helpful to label the cables so you can easily distinguish one from another.

DIRECT CONNECTION

Using the USB cable that came with your camera (**Figure 8.2**), you simply plug one end into the camera and the other end into your computer. Once you get everything connected, make sure your camera is powered on. With some camera models, you may actually have to switch the camera into playback mode for it to be recognized by your computer.

The USB end connects directly to your computer

The other end connects directly to your camera

FIGURE 8.2
USB cables like this connect your camera to your computer. Although the USB side is universal, the part that connects to the camera varies from model to model.

Keep in mind that your camera will need to remain powered on during the entire image transfer process, thereby draining your batteries. (Bummer!) You can conserve power by making a conscious effort to remember to shut your camera off once the process is complete.

CONSIDER A CARD READER

Whenever you connect your camera directly to your computer via a USB cable, there's a good chance you'll forget to shut the camera off once you finish transferring the files. This means it might be left on the whole time you're perusing your handiwork, oohing and aahing over all your great shots, and the batteries may be dead the next time you need the camera. For this reason, a card reader is highly recommended. (See the next section.)

CARD READERS

I've made several house calls to folks in digital photo distress who could've benefited from one of these little gizmos! Card readers, like the one seen in **Figure 8.3**, act as a go-between, helping move data from the memory card to the computer. Card readers offer two great benefits: You don't have to keep track of which USB cable belongs to which camera, and you don't drain your camera's batteries while transferring the files. Pretty cool, eh?

A card reader plugs directly into your computer the same way your camera's USB cable does when downloading with a direct connection. So, instead of plugging in your camera, you put your memory card inside the corresponding slot on the card reader, then plug the card reader itself into the computer. No camera required!

Card reader models vary in terms of data transfer speeds and the types of memory cards they accept. In most cases, however, you can get your hands on one starting for around $10 from most any place that sells cameras. They're a great buy, especially if you shoot with a camera that uses compact flash (CF) cards. (Card readers that are built into computers don't accept CF cards.)

The USB cable connects
to your computer

Your memory card goes into
the corresponding slot

FIGURE 8.3

Card readers are a convenient tool for downloading images. Some models accept a wide variety of memory card formats, whereas others take only a single type. The one pictured here reads both SD and CF cards, so I can use it whether I'm downloading from my point and shoot or my dSLR. The small size makes it great for travel, too!

BUILT-IN CARD READERS

Depending on the make and model of your computer, it may come with the convenience of a built-in card reader. The reader is often located on the side of the monitor, the edge of the keyboard, or possibly next to the USB ports. Most newer laptops have them, too.

Like external card readers, built-in card readers also vary from system to system and may accept a wide variety of memory cards or only a specific format. If you're looking to purchase a new computer, and having a built-in card reader is important to you, be sure to check the compatibility between the type of card(s) the computer will read and what your camera requires.

EYE-FI

If you'd rather give the cat a bath (yikes!) than spend even a single moment sitting at the computer, drudgingly downloading images, an Eye-Fi card may be your most convenient (and fun) option of all!

A special kind of SD memory card, it looks and behaves just like a regular SD memory card, except for the fact that when your camera is anywhere within your established Wi-Fi network, the images will *automatically download themselves.*

Yep. You read that right. No hassles. No cables. Not even a card reader. Your photos will download themselves.

In fact, in addition to transferring themselves to your computer, you can set it up so that the images are automatically posted to photo-sharing sites including Facebook and Flickr, as well as popular printing sites such as Shutterfly, Snapfish, and Kodak Gallery—*instantly.*

Check it out at www.eye.fi.

DOWNLOADING YOUR FILES

Once you connect the memory card to your computer, you have multiple options for transferring your files. If you're like many people, you've probably amassed quite the collection of camera software over the years—because each new camera you buy typically comes with additional software. Eventually, it can feel like a mess.

Believe it or not, you don't actually need software of any type to download your photos. You can just drag and drop files from your camera to your hard

drive, whether you're on Windows or a Mac. Heck, you can even copy them into whatever folder you want. But, as efficient and clean cut as dragging and dropping can be, a good image-editing or file-management program will also help you manage and organize your photos in addition to downloading them.

There are countless programs to choose from. As you already know, there's the software that came with your camera, various free programs such as Picasa, and more robust solutions (including Photoshop Elements and the rest of the Adobe product family). Although these programs vary dramatically in some aspects, they're each capable of helping you download images from your memory card to your hard drive.

Regardless of which software (if any) you choose to use, keep in mind that while your photos will be stored on your hard drive, they're not stored *within* the software itself. Even though you may use the software to view, interact with, and possibly even edit your images, the software itself is not a storage space—just a database that references your images, wherever they happen to be stored on your hard drive. (It's similar to how the computer system at the library keeps track of all the books on the shelves. You could remove the computer system from the library, but the books would still be on the shelves, right where you left them.)

You may be reading this and thinking, "Duh!" But the reality is, even people who understand this concept sometimes have irrational fears about removing or switching software, afraid they're inadvertently delete or otherwise lose their photos. Just to be clear—the only thing you would lose if you uninstall any camera/photo software would be any organizational structures you created within the software (such as image tags and keywords). But your images? They stay right where they are.

WHERE EXACTLY DO THE PHOTOS GO?

The specific location on your hard drive that your images are downloaded to is really up to you! Most software programs automatically default to downloading each batch of images into a new folder created within your Pictures (or My Pictures) folder.

Unless you change the default settings and name the folder something specific like "Colorado Yurt Trip," the new folder will most likely be automatically named with the download date. For example, if you downloaded photos on April 4, 2011, the folder might be named "2011 04 18," or some such variation. If you prefer a different folder naming structure, you can

probably specify that in preferences or customize the folder name each time you perform a download.

Every software program is different, but generally you'll find a screen that looks something like **Figure 8.4**, captured from the Photoshop Elements standard download dialog box.

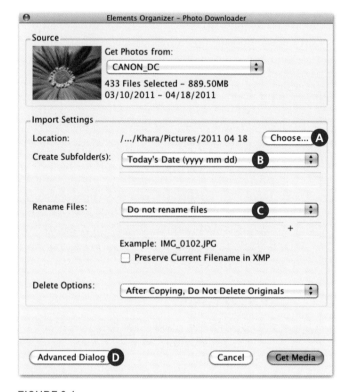

FIGURE 8.4

The standard Photoshop Elements download window makes it easy to specify where and how you want your images saved, name your own subfolders, rename your images, and more!

A Location refers to where (on your hard drive) the photos will be downloaded. In this example, they will go into the Pictures folder and be put within a subfolder named: 2011 04 18 (the download date).

B If you wanted to change the name of the subfolder to something other than the default setting (usually the current date), this is where you would do it.

C The option to rename your images as you download them often includes the ability to add a descriptive phrase and/or numerical sequence such as Colorado_001, followed by Colorado_002, etc. (In this example, the images are not renamed.)

D Some software programs offer additional options in an advanced dialog window.

Some software programs, like Photoshop Elements, offer additional options—as well as thumbnail previews—in an advanced dialog box, usually accessible from within the basic or standard dialog box. Look for a button or link labeled "more options" or "advanced" for helpful features like being able to preview image thumbnails, sort into groups, or add custom metadata.

Whichever software you use, make sure to pay close attention to the settings for the location and subfolder, as this is where you tell the computer which root folder to store your photos in and what you'd like the subfolder to be called.

The text that appears next to "location" is the path that leads to where your photos will be stored on your hard drive. Each forward slash (/) represents a folder. Collectively, this string of text is referred to as a "file path." A file path such as User Name/Pictures/2011 04 18 tells you that the photos you're about to download will be put into a folder named 2011 04 18, inside your Pictures folder, on your hard drive.

Knowing the path means you'll know where to find your images if you later decide to uninstall the software. Instead of saying, "Help! Where the heck are my photos!?" you could be asking, "Honey, which one of these cute shots of the kids should we put on the holiday card this year?"

WHAT TO DO WITH THE MEMORY CARD?

Some image-handling programs give you the option to automatically delete the original files from your memory card after they're downloaded. While this may sound convenient, it's generally not a good practice. If something goes wrong during the file transfer, and you let the software delete the original files from your card, you could have a serious problem.

NO, REALLY—DOWNLOAD YOUR IMAGES OFF YOUR MEMORY CARD!

Don't be a download slacker! Sure, it's easy to let your images pile up on your memory card for months and months at a time. But the sooner you get them downloaded, the sooner you can get them backed up, and the safer they'll be. (Next, we'll discuss the details on backing up your files.)

Therefore, once your images have been downloaded, verified, and backed up (which we'll cover in the next section), it's recommended that you use your *camera* (not the computer or any of the options in your software program) to reformat the memory card, clearing and resetting it for additional use. (This function is typically found within your camera's menu system. Check your user guide for details.)

At this point, you might be thinking, "But memory cards are so cheap these days. Doesn't it make sense to just buy a new one and keep the used one as an additional backup?" Perhaps—until you ask yourself where you'd store all those little memory cards (in a shoe box?) and how you'd know which one to reach for if disaster struck and you were looking for a specific image.

If it helps you sleep better at night knowing you've got a copy of your photos on a memory card somewhere, then more power to ya (the card manufacturers certainly won't complain!). But for security and convenience, I'd still recommend a more robust backup system. The next section will help you with that.

BACKING UP: AUTOMATION IS YOUR FRIEND

It goes without saying that backing up your digital life is a good idea. As the expression goes, "It's not a question of *if* your hard drive will fail, but rather, *when*."

The problem is that most people put it off—if they do it at all—which obviously defeats the whole purpose. Like preparing your taxes, taking the recycling out, or investing in your 401(k), backing up your data is something that just needs to be done.

The key is to automate the process so that once you get it set up, the backups will take care of themselves—and you can focus your attention on more exciting things. (Now, if only preparing taxes and taking the recycling out could be equally self-sufficient…that'd *really* be something!)

EXTERNAL HARD DRIVES

External hard drives make it easy to duplicate the contents of your entire computer so that all your data (not just your photos) will be safe in the event that your system fails. They're small (**Figure 8.5**), easy to set up, and available at any computer or office supply store.

FIGURE 8.5

This 2-terabyte external hard drive makes it easy to keep all my most critical files backed up (and it cost less than $150). It's shown here next to a mouse for size comparison.

The backup drive you choose should be equal to, or larger than, the capacity of the hard drive you'll be backing up. So if you want to back up a 1-terabyte internal hard drive, you'll need at least a 1-terabyte external hard drive to fit everything on. Drives are getting less and less expensive every day, so it's reasonable to expect to find one that suits your needs for $50–$150 (or even less).

BUT SERIOUSLY, ARE BACKUP DRIVES REALLY WORTH IT?

If you think $50–$150 for an external backup drive sounds crazy, consider the fact that restoring lost data from your hard drive could easily cost $1500 or more.

BACKUP SOFTWARE

Once you have an external drive to back up your data to, you'll need software to make it run on auto-pilot. The drive you choose may come with backup software included, but if it doesn't—or if you're not a fan of what it comes with—you can always take advantage of what's already on your computer. The current versions of both Windows and Mac operating systems include built-in backup applications:

- On Windows, find it by going to the Start menu and typing "Backup and Restore" into the search field. (If you don't get any results, search again using just the word "Backup.")

- On a Mac, the backup application is called Time Machine, and you can find it at Finder > Applications > Time Machine.

Whichever platform you're on, you'll have the opportunity to specify a backup location (the drive you want the backup data to be stored on), as well as set a schedule for how often and at what time you want the backups to occur. For best results, consider backing up your system on a daily (or even hourly) basis.

Figure 8.6 shows the Mac Time Machine interface. The software backs up your system on an *hourly* basis, which can be extremely handy not only in the case of a hard drive failure, but also in the event that you delete a file by mistake, or accidentally save one file over another (who hasn't done that at least once?). If hourly seems to slow down your computer, you can create manual backups whenever you want. (Unfortunately, those are the only Time Machine options—automatic hourly or manual on demand.)

Keep in mind that the initial backup of your data will take substantially longer than regular maintenance backups (because it's the first time all the information is being transferred). After that, the software is smart enough to know which files have been changed or added since the last backup, and only those files are backed up.

FIGURE 8.6
Backup software, such as the Mac's Time Machine, is simple to use and makes file recovery a breeze.

THIRD-PARTY SOLUTIONS

As any Google search will quickly confirm, the list of backup solutions available is pretty extensive. You can try out some applications for free before making a purchase. Key features to look for include:

• Easy setup

• Easy recovery

• Automation with scheduling options that fit the way you live/work

• Support in case you need help or have additional questions

Windows users may want to check out: Genie Timeline Home (www.genie-soft.com)

Mac users may be interested in: ChronoSync (www.econtechnologies.com)

The most important thing is that you get started—today.

WHEN THE UNTHINKABLE HAPPENS

Whatever you do, *don't* attempt data recovery on your own without talking to a professional first—or you could make things worse, reducing your chances of a successful recovery.

The team at DriveSavers (www.drivesaversdatarecovery.com) is among the best of the best. Their heroic data recovery specialists can be reached at 800-440-1904 and are great at explaining your options and helping you understand your chances of getting your digital life back.

But be prepared, it could cost you a very pretty penny. I once had a memory card recovered and it cost me upward of $1200 (even with a professional discount). Even though my experience with DriveSavers was phenomenal, I couldn't help but agree when my recovery hero said, "We hope you never have to call us again."

ONLINE BACKUPS

If the idea of setting up an external hard drive has your stomach in knots, or if you want a second layer of protection—even an external hard drive won't protect your data if your computer is stolen or destroyed—an online backup system might be a good match for you.

Online backups operate much the same way as external hard drives, except that your data is backed up to a remote storage system via the Internet. No drives for you to buy, no additional hardware on your desk, and total peace of mind.

Companies such as Mozy (www.mozy.com), Carbonite (www.carbonite.com), and Backblaze (www.backblaze.com) make online backups ridiculously easy and affordable by offering *encrypted* backups of your personal computer starting at less than $60 per year. That means, not only is your data backed up, it's kept private.

The only catch is that you need a reliable, high-speed Internet connection. If you live in an area with slow Internet, this may not be a viable option.

BEST PRACTICES FOR DATA TRANSFER AND BACKUPS

The data recovery specialists at DriveSavers provided these tips to help keep your photos as safe as possible.

1. Back up your images! Protect yourself by backing up regularly. This helps guard against data loss when (not if) your hard drive crashes unexpectedly.

2. Transfer your photos. Download the images from your memory card to your hard drive as soon as possible. Be sure to wait until all photos are transferred and verified before reformatting the card.

3. Follow instructions. Always remove memory cards from your camera (or card reader) carefully. To prevent the accidental deletion or corruption of images, use the eject command on your computer (or drag the card icon to the trash/recycle bin) before physically removing the card.

4. Verify the transfer. Open the images on the hard drive before reformatting the memory card.

5. Make more than one copy. Back up your backup, keeping a duplicate off-site in a secure location.

6. Protect your Flash memory cards. Use their plastic cases when carrying them around because simple static buildup can zap them, making the cards unreadable. Also, keeping memory cards in your pockets puts them in danger of being broken or run through the washing machine.

7. Replace your Flash memory cards. Typically, Flash memory cards can be used about a thousand times before they start to wear out.

8. Avoid extreme temperatures. Heat, cold, and humidity can wreak havoc with digital equipment, especially Flash memory.

(Courtesy of DriveSavers Data Recovery)

WHAT ABOUT CD/DVDS?

Using CDs or DVDs to transfer files or make a slideshow for your cousin's wedding is one thing. But when it comes to keeping your data safe and current, burning CDs or DVDs isn't practical for several reasons:

- There's no way to automate the process. The discs only get burned when you take the time to sit down and do it. (Don't kid yourself. Automation is a must!)

- CDs and DVDs are not high-capacity storage devices. The memory card in your camera likely holds more data than you could fit on one of these discs (even a dual-layer DVD only holds about 8 gigs of data). That means you may have to burn *multiple* discs each time you're ready to back up another memory card (not to mention having to figure out a way to label, sort, and store them all).

- Reports vary, but some experts say CDs and DVDs may only be readable for approximately five years, making them a poor choice for long-term archival purposes.

Bottom line? Burning discs is generally not a viable or sustainable backup solution. Invest in an external hard drive and/or online backup solution instead.

MOVING ON: ORGANIZING, SHARING AND PRINTING YOUR IMAGES

Congratulations! If you've made it this far, not only are your photos looking better than ever, but they've also successfully made the journey from your memory card onto your hard drive, *and* have even been backed up for safekeeping. You should be proud.

But the fun certainly doesn't end there! So let's dive in and discuss organizing, sharing, printing, and editing your great shots.

GETTING ORGANIZED

While it's great knowing that your images are copied to your hard drive and safely backed up, it's *even better* when you also know how to find them without having to enlist a search-and-rescue team for assistance.

The software you're using to download your photos likely also includes some tools to help you keep track of them. If not, you might want to check out one of these popular choices:

- Google's Picasa (http://picasa.com), free, Mac/Windows

- Windows Live Photo Gallery (http://explore.live.com/windows-live-photo-gallery), free, Windows only

- iPhoto (www.apple.com/ilife/iphoto), free (depending on your Mac, it may already be installed) or $49 upgrade, Mac only

- Adobe Photoshop Elements (www.adobe.com/products/photoshopel), $99, Mac/Windows (for more information on this software, see the "Editing your photos" section later in this chapter).

BUT REALLY, WHICH SOFTWARE IS BEST?

Although many programs have tools for tagging, labeling, and otherwise cataloging your images, Adobe Photoshop Elements stands heads and shoulders above the competition.

Known for its editing prowess, Photoshop Elements also impresses with its organizational tools. For around $99, it's the consumer-friendly version of what the pros use, and chances are it won't take you long to see why it's in a class all its own.

You can download a free 30-day trial from www.adobe.com/products/photoshopel.

Ideally, you should spend a few moments organizing your images immediately after downloading them. To make things as efficient and painless as possible, it helps to use the same software for both downloading and organizing—so that as you continue to add new images to your hard drive, they'll automatically be included in your photo catalog. (Another reason Photoshop Elements is so cool—you can actually set up "watched" folders so that even if you use other software to download new images behind Elements' back, it will notice and add the new photos to your catalog the next time you launch it. Software that's powerful *and* smart? Yes please!)

THE VALUE OF A PHOTO CATALOG

Whichever program you decide to use for managing photos, remember that regardless of where your photos are stored on your hard drive—or how you ultimately end up organizing them—they are not saved within the photo-management program itself. Moreover, as you work on organizing them, you can rest easy knowing that the software isn't moving or scattering them around on your hard drive either.

Unlike when you organize your closet (potentially moving things all over the place), photo-management programs work by cataloging images from across your entire hard drive, then displaying them all in a single location. So even though your *actual* image files are stored in a variety of folders, the software makes it possible to view, label, tag, group, and sort all your photos *in one place*. Pretty cool, eh?

Because of this, your image catalog becomes a very powerful and search-able database. Similar to how the computer system at your local library keeps track of all the books and their respective locations on the shelves, your cata-log can help you find whatever images you're looking for in a flash.

For example, let's say you're creating a slideshow of images for your friend's birthday, and want to pull up every photo you have of her before deciding which ones to include. Without a good organizational program, you'd have to *manually* dig through each individual folder that could possibly contain an image of her. Yuck.

In fact, let's say you're the type of person who diligently creates custom names for each folder every time you download new images, and you already have the images you want to use in mind, and you happen to know the exact folder they're stored in. Even still, your slideshow project could quickly turn into a nightmare because you can only look through a single folder of images at a time. At this rate, gathering images for a three-minute slideshow could become an all-day affair!

But, with a good photo-management program—and a keyword tag for your friend—you can easily filter your images to pull up all the relevant photos from across your entire system in an instant. Score! That slideshow project of yours just got a whole lot easier, didn't it?

To get an idea of how this looks in action, check out **Figure 8.7**, showcasing the organizer workspace of Photoshop Elements. If I wanted to surprise Emir with a collection of images featuring the two of us together from our trip to Morocco, it would be as easy as three clicks:

1. One click to filter for images of Emir

2. A second click to cross-reference images of Emir with images of myself (returning only images that feature us both)

3. A third click to turn up only those images that meet the above criteria and are tagged with the keyword "Morocco"

FIGURE 8.7
Keywords and tags make it easy to find anything you're looking for in a hurry, even adding the ability to cross-reference images and fine-tune your results. In this case, 400-plus images are instantly filtered down to 12, displaying only the ones from Morocco that feature both Emir and me.

A This filters for images that include Emir.

B This filters for images that include me.

C This filters for images captured in Morocco.

D In Photoshop Elements, performing a search is as simple as clicking the box next to the tags/keywords you want to search for. Clicking a second time cancels the search.

E Out of more than 400 images in this catalog, 12 images meet all three search criteria.

Tagging your photos in an organizational program is similar to tagging them on Facebook, except that you can create tags for anything you want—not just people, but also places, events, and whatever else you can think of!

Of course, tags, labels, groups, and keywords are helpful only if you actually *use them.* If you make it a habit to spend a few moments tagging/keywording your new images each time you download them, you'll be able to find them in a flash later. (Some programs will help you automate the process with cool features such as face recognition, batch tagging, and more! Be sure to explore the tutorials and support materials for whatever program you decide to use.)

RECONCILING A MESSY PAST

When people realize the value of having organized photos, their eyes often grow big with excitement as daydreams of quick searches and new photo projects dance about in their heads.

This newfound enthusiasm is sometimes followed by an overwhelming sense of panic as they come to terms with what might be involved in working backwards to organize a lifetime of accumulated digital photo messiness.

Generally, you have two options for moving forward:

- Work backwards little-by-little to organize your past digital life over the course of several weeks or even months. This doesn't have to be as bad as it sounds—in fact, it will likely involve the rediscovery of forgotten images and can lead to several fun trips down memory lane. Just be sure to give yourself plenty of time so you can enjoy the process and not feel rushed.

- Let bygones be bygones and make peace with your messy photo history —just make sure to do a better job of keeping track of your images from this day forward.

Feeling overwhelmed? Here's a ray of hope! Even if your past images aren't tagged (and never get tagged), as long as you include them in your catalog, you can still use programs like Photoshop Elements to search for and find them using other factors such as their capture date (assuming you had the date/time set correctly in your camera), as seen in **Figure 8.8**.

FIGURE 8.8
Photoshop Elements has several features for finding images based on the date they were captured. The Dateview option plots your photos to a virtual calendar so you can view a day's, month's, or year's worth of photos at a time.

In other words, even if your existing photos never quite get organized to the degree you'd like, they can still be located on demand, so don't write them off and count them out. (Instead, maybe you can let them inspire you to maintain a more organized photo future?)

PULLING DOUBLE DUTY

In addition to helping you download and organize your images, most photo-management programs will help you with many other tasks—including sharing them online via sites such as Flickr and Facebook, ordering prints from a collection of popular providers, and creating a variety of projects like slide-shows, calendars, books, and more. For that reason alone, it's nice to have.

Bottom line? It's worth investing in (and using) good photo-management software.

WHAT IF YOU WANT TO BREAK UP WITH YOUR PHOTO-MANAGEMENT PROGRAM?

As mentioned earlier in this chapter, even though your photos would stay where they are and wouldn't disappear if you decided to remove (uninstall) your software, you *would* lose any tags, labels, and virtual groupings you created using the software. (This would most likely require you to start over from scratch in whatever software you decide to use next.)

Best advice? Many programs offer a free trial you can download and test out *before* committing. This makes it easy to find one you like so that when you do, you can roll up your sleeves and move forward with gusto!

SHARING YOUR PHOTOS

Of course, part of the fun of capturing great images is being able to share them with others. These days, it's easier than ever before to connect with family, friends, and other shutterbugs to share everything from your day-to-day snapshots to your most prized photographs.

Most photo-sharing websites are free and provide all kinds of options for controlling access to your images, enabling you to share them with the whole world or limit them to an exclusive audience. Some of the most popular sites include:

- Flickr (www.flickr.com)

- Shutterfly (www.shutterfly.com)

- Photobucket (www.photobucket.com)

- Snapfish (www.snapfish.com)

- Kodak Gallery (www.kodakgallery.com)

Because of the popularity of Facebook (in addition to dedicated photo-sharing websites), some retailers and in-store kiosks also let you print images directly from your Facebook albums, thereby further expanding your options (while also potentially streamlining your efforts).

Whatever site you choose, the process of sharing your images generally includes uploading them to a virtual album, tagging them as needed, and sending a link to family and friends so they can view them—and maybe even order their own prints if they're so inclined.

If you're really serious about showing off (and maybe even selling your images), for as little as $40 per year, SmugMug (www.smugmug.com) will give you your own themed photo website with a long list of additional options and features. As a member, you would also have access to the SmugMug User Groups, an extended community of local professional photographers as well as general photo enthusiasts who get together to mix, mingle, and talk about all things photo.

PRINTING YOUR MEMORIES

These days, with the proliferation of online photo-sharing websites and digital media, you may wonder why anyone would bother printing images anymore. As it turns out, printing your photos is possibly more important now than ever before.

GATHERING 'ROUND THE HARD DRIVE HEAP?

The digital evolution continues, and as exhilarating as it is, it's hard to say what things will look like 10, 20, or 30 years from now. In fact, it's possible that the digital services we know and love today could be entirely nonexistent tomorrow. Where would that leave us—and all our images? Despite the advantages of digital images for archiving, organizing, and sharing our memories, *printed* photos provide a tangible and abiding connection to the past in a way that is yet to be rivaled onscreen.

Maybe it's because we relate differently to things we can hold and touch versus things with only a virtual existence? Or perhaps it's because of the natural charm photos take on as they age, worn with love and the passing of time? No matter the reason, there's nothing quite like going through your grandmother's attic and discovering a collection of photographic family treasures like the photo seen in **Figure 8.9**. (Somehow, stumbling upon a heap of hard drives doesn't have quite the same effect.)

If you think building a legacy of photographic treasures for your family to enjoy sounds like an overwhelming fantasy, think again. The process can be as simple as routinely ordering prints of a handful of your favorite images every time you download new photos from your memory card.

Slip the prints into a photo album, and you'll be set. It doesn't have to be any more complicated than that! The important thing is that you actually do it.

FIGURE 8.9
What format will the future generations of your family find your photos in? (Frame from www.obrienschridde.com, photo by Emir Plicanic)

EXPLORING OUTPUT OPTIONS

If you're already uploading images to photo-sharing websites, it's easy to order prints directly through them or their affiliates. Depending on the site you use, you might be able to choose between having the images shipped to you or picking them up locally.

It's important to know that print quality—tonal range; color reproduction; the weight, texture, and finish of the paper; and the longevity of the print itself—can vary dramatically not only from lab to lab, but in some cases, even from day to day, depending on who's behind the counter.

When a high print quality is more important than a one-hour turnaround time, check out the options from Mpix (www.mpix.com). They make professional quality prints affordable and available to anyone with an Internet connection. (And they'll deliver them faster than you would imagine!)

If you're among those who aspire to print everything yourself at home, you might want to reconsider. While some people take great pride in printing their own images, the costs involved in doing so are often greatly underestimated. With the potential for large amounts of wasted ink and paper (not to mention the inevitable troubleshooting, setup, and connectivity issues), printing at home can end up costing considerably more than you think. (I'd vote for a good lab over home printing any day!)

Looking for something different? In addition to the photographic prints you're familiar with, your photos can live on in a variety of formats, including canvas wraps (see www.mpix.com), photo jewelry (check out www.planetjill.com), handbags (try www.ginaalexander.com), custom-printed photo books (available from most photo retailers), and more.

Over time you'll discover what photo paper you like the best, which shop offers the most book options, and who's able to get things to you the fastest when you're in a pinch. It pays to look around, explore, and experiment!

If you're looking for high-quality photo books with additional options for paper finishes, cover choices, and total control over layout, check out the neat things the folks over at Blurb (www.blurb.com) are offering.

Once you've got your book put together, you even have the option of making it available for others to purchase in Blurb's online store! (Kinda makes you extra excited about your newly found photo know-how, doesn't it?)

And, if you're a blogger, depending on the platform you use, you may be able to take advantage of Blurb's incredible option to "slurp" your blog into a book—making it possible for your images (and the written stories that go with them) to exist in digital as well as printed format. Who would've thought you could create a tangible version of your blog? So cool!

EDITING YOUR PHOTOS

Let's face it—playing with photos can be *fun.* Although the software that came with your camera might help you with basic image editing such as resizing, removing red-eye, and converting to black and white, if you *really* want to get your hands dirty (covered with pixels, of course!), there's only one place to turn: Adobe.

Many people are familiar with the 600-pound behemoth of an editing program known as Adobe Photoshop. It's widely recognized as the cutting-edge industry standard, and as you would expect, it carries a professional-grade price tag, weighing in at close to $700.

Luckily, the brilliant people at Adobe recognized that it's not just professionals who are interested in robust software solutions for image editing, but most people with a digital camera! In response, they developed Photoshop Elements—the budget-friendly, consumer version of Photoshop that I've lovingly mentioned (quite a few times) throughout this book. The best part? It's available for less than $100.

But don't let the friendlier price tag fool you—Photoshop Elements is no joke. It packs a full punch of editing power, enabling you to not only adjust simple things such as the color and tone of your images, but also create elaborate composites and special effects. Photoshop Elements also provides an exhaustive collection of tools for everything from adding text to your photos to performing sophisticated restoration and retouching.

Earlier in this chapter, you a caught glimpse of the Photoshop Elements *downloading* interface. And then we looked at a preview of its *organizing* workspace. Lastly, you can get a feel for its *editing* workspace, shown in **Figure 8.10**.

FIGURE 8.10
A more wallet-friendly version of full-blown Photoshop, Photoshop Elements packs a full punch of photo-editing power without bruising your bank account.

Because Photoshop Elements is so darn sophisticated, it can be enormously helpful to get some assistance in learning how to use it. Thankfully, good help is easy to find from sites such as Photoshop Elements User (www.photoshopelementsuser.com), which features an online collection of tutorials and a magazine dedicated to teaching you all things Photoshop Elements.

You can also find some great books to help you get up to speed with Photoshop Elements in a jiffy. If you're a total beginner, check out *Photoshop Elements: The Missing Manual* by Barbara Brundage. If you have a good grasp of the basics and are looking for more advanced techniques to take your skills to the next level, pick up Scott Kelby and Matt Kloskowski's book, *The Photoshop Elements Book for Digital Photographers.*

Once you've got the software, some images, and a point in the right direction, get ready to roll up your sleeves and have fun!

DOES THE SOFTWARE VERSION REALLY MATTER?

Software manufacturers release new versions of their programs every year or so. The differences between one version and another aren't usually worth losing any sleep over. Typically, there are improvements to things like functionality and performance, along with the possibility of a few new features here or there—but it's not as if switching from one version to another will be so incredibly different that you'd feel lost.

Ultimately, just as you shouldn't be afraid to upgrade if and when it makes sense, you also shouldn't be afraid to take advantage of any great deals you may find on earlier (retired) software versions as retailers try to clear the shelves to make room for upcoming new releases.

YOU DID IT!

That wasn't so bad, right? Aren't you surprised by how much potential your camera has had all along? Admit it. It's pretty incredible.

Like the announcer on a late-night infomercial, I feel compelled to say, "But wait! There's more! If you call now…" Just kidding.

But seriously. Before we part ways, there are a few more odds and ends worth knowing about. Good stuff!

PHOTOGRAPHIC DIY HEAVEN

Now that you know and understand the basics, the party can live on indefinitely as you and your camera spend more and more quality time together. How exciting is that?

If you're *really* looking to have some fun with your camera, you absolutely, without a doubt, need to check out www.photojojo.com. They have tutorials on all kinds of fascinating photographic techniques (camera toss, anyone?), DIY decorating ideas, and one-of-a-kind goodies you'd be hard pressed to find elsewhere.

Looking to treat yourself in celebration of your newfound photo know-how? Check out *Photojojo! The Book: Insanely Great Photo Projects and DIY Ideas,* by Amit Gupta and Kelly Jensen. You deserve it!

KID IN A CANDY STORE

People often ask me where I buy my cameras and photo-related equipment, and I have only one answer for them: B&H (www.bhphotovideo.com). Their unbeatable combination of selection, price, product reviews, educational resources, knowledgeable staff, and easy-to-find-what-you're-looking-for website is, quite simply, the best.

If you live in (or have plans to visit) New York City, make it a point to stop by their flagship store on 9th Avenue at 34th Street. You can get your hands on pretty much anything in the store (230,000-plus products!) while surrounded by staff who are happy to help.

My first experience in their store was so inspiring, I actually wrote an entire blogpost about it. (If curiosity is getting the better of you, you can check it out here: www.kabloomstudios.com/blog/my-kind-of-disneyland).

TIME FOR NEW GEAR?

Eventually, even the most beloved and well-cared-for camera will reach the end of its life expectancy. Having to say goodbye to a dear friend is never easy—but getting to know a new one can certainly be exciting. With a long list of possibilities, however, where do you start? There are so many factors to consider—available shooting modes, lens options, price (just to name a few)—that the options can easily be overwhelming.

To help, I've put together a list of the gear I recommend and use in my own pursuits, both personally and professionally. Everything from my well-loved point-and-shoot cameras to my favorite dSLRs, camera bags, and tiny, travel-size tripods. You'll find it all on my website (www.kabloomstudios.com/gear). Enjoy!

XOXO!

I hope this book has infused you with a sense of empowerment.

You *can* make better photos. You *can* take control and boss your camera around. And—you *can* have fun in the process.

Cheers!

Chapter 8 Assignments

Download Those Images!

Okay, be honest. Do you have images sitting on your memory card from last year's holidays? Get them off your card and onto your computer! Organize them into a folder (or folders) and pat yourself on the back as you take a look at your handiwork on the big screen!

Back It Up

Now you've got your images on your hard drive. Now what? Remember, it's not a matter of *if* that hard drive will fail one day, but *when*. Review the backup procedures outlined here and come up with a backup solution for yourself. It involves a little work up front, but once it's automated it's a piece of cake. Well worth it.

Make a Print

Have you ever made a nice big print of a few of your favorite photos? Give it a try. If you think your best shot looks great on a small screen, just wait til you see it at 8 x 10 or 11 x 14! Believe me, you'll quickly get hooked on printing your images!

Share your results with the book's Flickr group!

Join the group here: flickr.com/groups/gettingstartedfromsnapshotstogreatshots

INDEX

WATCH READ CREATE

Unlimited online access to all Peachpit, Adobe Press, Apple Training and New Riders videos and books, as well as content from other leading publishers including: O'Reilly Media, Focal Press, Sams, Que, Total Training, John Wiley & Sons, Course Technology PTR, Class on Demand, VTC and more.

No time commitment or contract required! Sign up for one month or a year.
All for $19.99 a month

SIGN UP TODAY
peachpit.com/creativeedge